IMAGES
of America

CIVILIAN CONSERVATION
CORPS IN VIRGINIA

IMAGES of America

CIVILIAN CONSERVATION CORPS IN VIRGINIA

Joe and Patty Elton
Foreword by Joan Sharpe

ARCADIA
PUBLISHING

Published by Arcadia Publishing
Charleston, South Carolina

Printed in the United States of America

Library of Congress Control Number: 2016952671

For all general information, please contact Arcadia Publishing:
Telephone 843-853-2070
Fax 843-853-0044
E-mail sales@arcadiapublishing.com
For customer service and orders:
Toll-Free 1-888-313-2665

Visit us on the Internet at www.arcadiapublishing.com

This book is dedicated to our parents, Joseph Cox Elton Jr. and Barbara Mary (Draskovich) Elton, and James Richard Marsh and Mary Sweet Marsh, all members of the Greatest Generation.

CONTENTS

FOREWORD

In many respects, the history of our nation has its roots in Virginia. Without much effort, we can create a list of Virginia historical events that are clearly linked to the growth and development of the United States. Yet, there is another national history first in Virginia that is little known. It is a quiet piece of history. This history is still growing in the forests, walking with us on our recreational trails, refreshing us as we enjoy our parks, and teaching us to appreciate the beauty of America. It is the Civilian Conservation Corps, and its legacy surrounds us in the valleys and vistas of our communities.

So, what is the CCC? A US Forest Service (USFS) ranger once told me the two most important things one needs to remember about the accomplishments of the CCC are:

1. It created the modern outdoor recreation system, and
2. It created the modern tenets of conservation that we still use today.

These things are all encompassing. Yes, the program did do those things.

It is not unusual for a CCC boy to say, "The CCC saved my life." Those living today are in their mid-90s. They sincerely believe that experience had such a profound effect on their lives that the youth of today should also have this opportunity.

The legacy of the CCC is more than parks, stone walls, forests, firefighting methods, and a long list of other things. During the Great Depression, this experience gave millions of young unemployed kids confidence, taught them job skills, exposed them to different cultures and geographical locations, and most of all created a lifelong trend to be good citizens who believed in community service.

One of the slogans that emerged from the early days at the CCC program at Camp Roosevelt was "We Can Take It." And, yes they did. They helped our nation through World War II, helped to restore America's infrastructure, and supported their community. They were proud to be a CCC boy, an American, and part of the Greatest Generation.

—Joan Sharpe

ACKNOWLEDGMENTS

Many sources contributed information and images for this historical account of the Civilian Conservation Corps in Virginia. We started our research at the CCC Museum at Pocahontas State Park. Joan Sharpe, director of the CCC Legacy in Edinburg, Virginia, provided access to their archives, shared numerous stories about CCC alumni, and wrote the foreword. Nancy Russell and Wade Myers were helpful at the National Park Service Historical Archives. Ann Hardy Beardshall, coauthor of 3 Hots and a Cot, provided background about Camp Cherokee in Bastian, Virginia. Lynn Spomer and Lydia Austin at South Dakota State Parks helped us acquire images of President Coolidge. Supt. Vidal Martinez and Lisa Lichliter provided valuable assistance with Prince William Forest Park's archives, and our dear friend Tom Wolfe of Arlington, Virginia, assisted with the National Archive collection. Several historical societies provided assistance, including Alleghany, Bland, Wythe, and Smyth. Brenda Gwyn of Marion was helpful in acquiring images and information about the camps at Hungry Mother State Park.

Virginia State Parks director Craig Seaver and his executive assistant Paula Hill provided much encouragement and research assistance. District manager Sharon Ewing, author of Images of America: *Virginia State Parks*, provided images. Westmoreland State Park manager Ken Benson arranged a meeting with CCC alumni Walter Atwood and Edward S. Slagle, author of *Recalling the Civilian Conservation Corps*. Tanya Hall and Amy Atwood at Hungry Mother, Charlie Connor and Amanda Elmore at Douthat, and Virginia Department of Conservation and Recreation's Kelly Cossey and Cyndi Juarez provided assistance with information and images about Youth Conservation Corps (YCC) and AmeriCorps. Interpretive program manager Sammy Zambon contributed historical images.

The Elton family was patient with us; especially our sons Alexander and his wife, Grace, and Lance and his wife, Kelsey, and their son—our first grandson—Trevor.

We have made friendships along the way with many who believe the Civilian Conservation Corps made the American dream a reality for a whole generation that needed a helping hand. We are especially grateful that Franklin Delano Roosevelt had the vision and leadership to make it a reality.

INTRODUCTION

The CCC was the antidote for a nation suffering from the Great Depression. Americans were living abundantly one year and were destitute the next. The stock market crash of October 1929 led to a quarter of the working-age population being unemployed. In the election of 1932, Franklin Delano Roosevelt promised change. His optimism and confidence contrasted greatly with Pres. Herbert Hoover. Despite being stricken with polio, Roosevelt campaigned aggressively and struck a chord with voters. He received 472 electoral votes to Hoover's 59. He had a mandate.

On March 4, 1933, Roosevelt was inaugurated president. The fate of a desperate nation was in his hands. He called a special session of Congress on March 5. The next day, March 6, he called a meeting of the secretaries of war, agriculture, and interior; the director of the bureau of the budget; the judge advocate general of the Army; and the solicitor of the Department of the Interior. He wanted to put up to 500,000 unemployed youth to work in CCC camps. He wanted the Army to run the camps. The Departments of Interior and Agriculture would develop the projects and provide the staff. The Department of Labor would select the enrollees. FDR was in a hurry. He sent a message to the 73rd Congress on March 21:

> I propose to create a Civilian Conservation Corps to be used in simple work, not interfering with the normal employment, and confining itself to forestry, the prevention of soil erosion, flood control, and similar projects.
>
> More important, however, than the material gains, will be the moral and spiritual value of such work. The overwhelming majority of unemployed Americans, who are now walking the streets and receiving private or public relief would infinitely prefer to work. We can eliminate to some extent at least the threat that enforced idleness brings to spiritual and moral stability. It is not a panacea for all the unemployment, but is an essential step in this emergency . . . I estimate that 250,000 men can be given employment by early summer.

On March 31, Congress authorized Roosevelt to move forward. Remarkably, on April 17—just 44 days after his inauguration—Camp Roosevelt, the first CCC camp, was established. On July 17, FDR made a radio address to the boys of the CCC, saying:

> Men of the Civilian Conservation Corps, I think of you as a visible token of encouragement to the whole country. You—nearly 300,000 strong—are evidence that the nation is still strong enough and broad enough to look after its citizens. You are evidence that we are seeking to get away as fast as we possibly can from soup kitchens and free rations, because the government is paying you wages and maintaining you for actual work.
>
> Through you the nation will graduate a fine group of strong young men, clean-living, trained to self-discipline and above all, willing and proud to work for the joy of working.
>
> Too much in recent years large numbers of our population have sought out success as an opportunity to gain money with the least possible work.

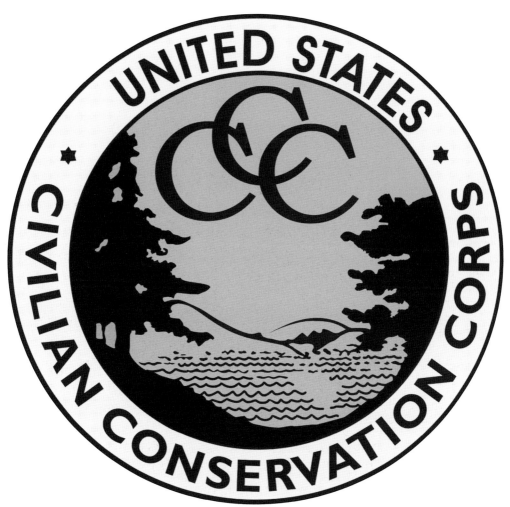

The Civilian Conservation Corps has been symbolized by this iconic logo for more than 80 years. It is universally used in association with all CCC programs including national forests, national parks, state parks, Tennessee Valley Authority, and Soil and Erosion Service. Small aluminum versions of this image have been placed on buildings within Virginia's state parks that were constructed by the boys of the Civilian Conservation Corps. (Courtesy of CCC Legacy.)

One

BOOM AND BUST

The 1920s was a decade of rapid change and innovation. Transportation, communication, fashion, and thought fueled a social and industrial revolution. Millions of people migrated from rural areas to cities. For the first time, more people were living in cities than in the country, and women had the right to vote. Jazz and dances like the Charleston had a liberating effect on the nation's young. New, more revealing attire spawned a generation of young women known as Flappers. They were dedicated to enjoying themselves and flaunting convention. They cut their hair, wore provocative clothes, and drank and smoked in public—all things that were abhorrent a generation earlier. Thanks to Prohibition, illicit clubs called speakeasies created an environment where many Americans violated the law.

Electricity powered many new inventions, including the phonograph, refrigerator, washing machine, telephone, and radio. These appliances made life easier and communication fast.

While society was changing and the country was booming, it elected mild-mannered conservative Calvin Coolidge as president. Coolidge believed a small and limited government would best serve the nation. Corporate firms prospered while the government presided benevolently over business. Profits reached record levels and markets engaged in many excesses of speculation. It was a boom time for the wealthy.

On October 29, 1929, it was obvious the 10-year economic boom was over, and America was ushering in a new era, a Great Depression, unlike anything the nation or world had ever seen. By 1933, one in four American workers were unemployed. It was a dark time.

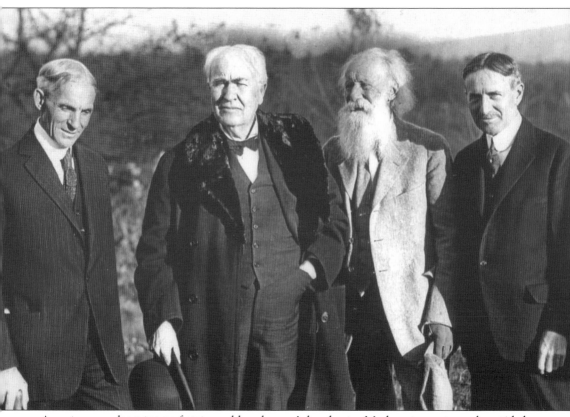

America was changing so fast it could make one's head spin. Modern inventions changed the way people lived and worked. The promise of the American dream seemed to be more real than ever before. Everyone was working, and big business was making money hand over fist. Electricity powered trolleys, and the electric lightbulb did away with oil lamps. The phonograph and radio brought news and entertainment into homes. Affordable Ford automobiles and a telephone hanging on the kitchen wall greatly enhanced travel and communications. It was an exciting time. The media covered the actions of the rich and famous, including, from left to right, Henry Ford, Thomas Edison, John Burroughs, and Harvey Firestone, who took annual motor camping tours of the country together from 1914 to 1924. (Authors' collection.)

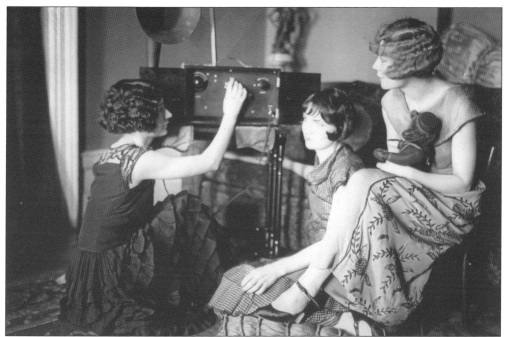

Pres. Grover Cleveland said, "No self-respecting woman would want the right to vote." But, the suffrage movement in the United States was gaining ground in the 20th century. It was not until August 26, 1920, that the Nineteenth Amendment granted the universal right to vote. It was empowering. With this fundamental right, a new era was ushered in, and women were embracing change with vigor. Equal rights impacted society in many ways. New, more revealing fashions launched a sexual revolution. The conservative lifestyles of their mothers were a thing of the past. The new fashions were derided by traditionalists. Those who wore short hemlines, costume jewelry, close-cropped hairstyles, and who drank and smoked in public were labeled flappers. (Both, authors' collection.)

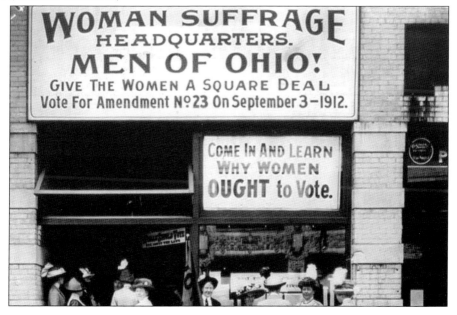

THE AMERICAN ISSUE

A Saloonless Nation and a Stainless Flag

Volume XXVI WESTERVILLE, OHIO, JANUARY 25, 1919 Number 4

U.S. IS VOTED DRY

36th STATE RATIFIES DRY AMENDMENT JAN. 16

Nebraska Noses Out Missouri for Honor of Completing Job of Writing Dry Act Into the Constitution; Wyoming, Wisconsin andMinnesota Right on Their Heels

JANUARY 16, 1919, MOMENTOUS DAY IN WORLD'S HISTORY

On January 16, 1919, the Eighteenth Amendment to the US Constitution was ratified; it became the law a year later. It started the era of Prohibition as a way to eliminate the unsavory results of drunkenness. It was the law of the land from 1920 to 1933. Calvin Coolidge was elected vice president on a ticket with Warren G. Harding in 1920. Harding died unexpectedly, and Coolidge was sworn in on August 2, 1923. He was elected to his own four-year term and served until March 4, 1929. Pictured below are Coolidge and US senator Peter Norbeck, a promoter of Mount Rushmore, Badlands, and the 70,000-acre Custer State Park. Coolidge made Custer State Park's State Game Lodge his "Summer White House" in 1927. (Above, authors' collection; below, courtesy of Custer State Park Archives.)

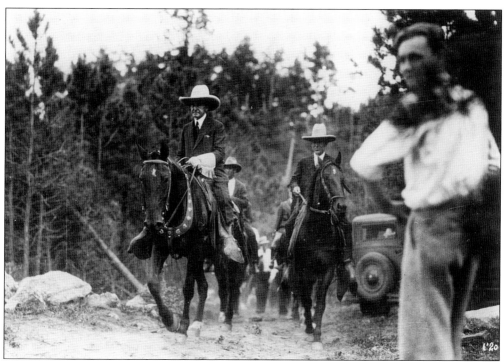

While he was at Custer State Park in the summer of 1927, Coolidge announced, "I do not choose to run for president in 1928. If I take another term, I will be in the White House till 1933 and ten years in Washington is longer than any other man has had it." He later said, "The Presidential office takes a heavy toll of those who occupy it. While we should not refuse to spend and be spent in the service of our country, it is hazardous to attempt what we feel is beyond our strength to accomplish." Coolidge spent the summer of 1927 relaxing and allowing business to take care of itself. He and his wife toured the Black Hills, took long horseback rides, fished South Dakota's streams, and attended rodeos and special events. (Both, courtesy of Custer State Park Archives.)

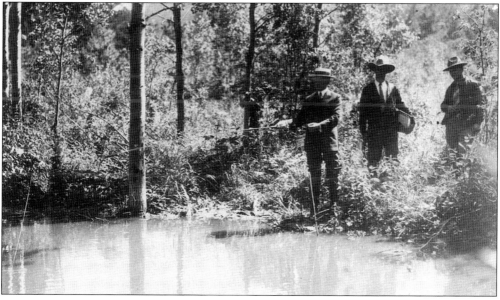

Coolidge, when asked about his successor Herbert Hoover, said, "For six years that man has given me unsolicited advice—all of it bad." Gov. Harry Byrd and William Carson, chairman of the Conservation and Development Commission, encouraged Hoover to establish a presidential retreat in the mountains. Hoover and his wife enjoyed clean mountain air and trout fishing on the Rapidan River. Byrd and Carson believed a presidential retreat in Virginia would give them opportunities to push for creation of Shenandoah National Park, one of Byrd's signature economic development ideas. The good times ended on October 29, 1929, and the Great Depression began. Unemployment rose to 25 percent. The country was scared, and the question on everyone's mind was where to go from here? (Left, courtesy of National Archives and Records Administration, Herbert Hoover Presidential Library; below, courtesy of CCC Legacy.)

WHERE DO WE GO FROM HERE? 6

Two

New Hope

Franklin Delano Roosevelt captured the hearts, minds, and votes of a nation looking for a "New Deal." Voters expected him to get the nation working. Roosevelt's mandate for change was huge—42 of 48 states went for him. He knew the public and Congress would give him a short honeymoon. He had to aggressively push his programs, and he did.

Roosevelt was inaugurated on March 4, 1933; on March 31, he signed the bill to authorize the CCC; and on April 5, he issued Executive Order No. 6101, organizing the CCC. In a month, he had the program going. He turned to existing agencies of the federal government, the Army, and the Departments of Labor, War, Interior, and Agriculture, and created a small office of Emergency Conservation. He appointed Boston native Robert Fechner, general vice president of the International Association of Machinists, to run it. Fechner had been a railroad machinist and had traveled over much of the country as well as Mexico and Central and South America. He understood the working man, having played a significant role in the effort to create a nine-hour workday in 1901 and an eight-hour workday in 1915. He had lectured at Harvard, Brown, and Dartmouth on labor economics. He first met FDR during World War I and was a familiar friend.

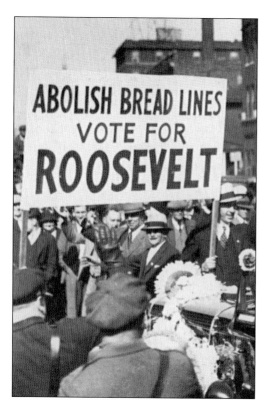

The Democratic Party at its 1932 National Convention in Chicago nominated Franklin Delano Roosevelt of New York for president and Speaker of the House John Nance Garner of Texas for vice president. FDR campaigned on a New Deal for the people of the United States. Government had a responsibility to help the nation combat the effects of the Great Depression. The time had passed when the nation would wait for the markets to heal themselves. It was time to act. The country was looking for bold leadership. (Left, authors' collection; below, courtesy of Smyth County Historical & Museum Society Inc.)

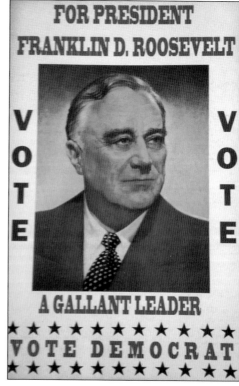

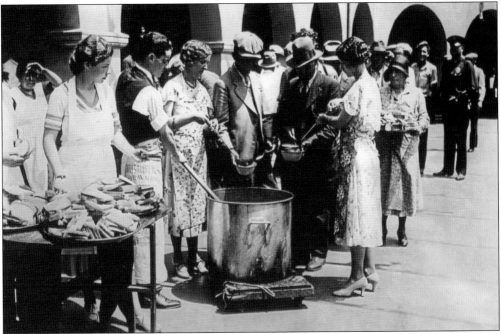

Soup and bread lines, established by churches and charitable organizations in neighborhoods throughout the county, were emblematic of the dire conditions that many experienced. Frightened citizens rushed to the banks to withdraw their savings. Proud families that did not want a "hand out" were forced by circumstances to take a "hand up" in order to survive the economic catastrophe that had been forced on them by a decade of greed and speculation. It was a humbling time. The country was ready to try something new. They needed something and someone to believe in, and they needed it badly in 1932. (Both, authors' collection.)

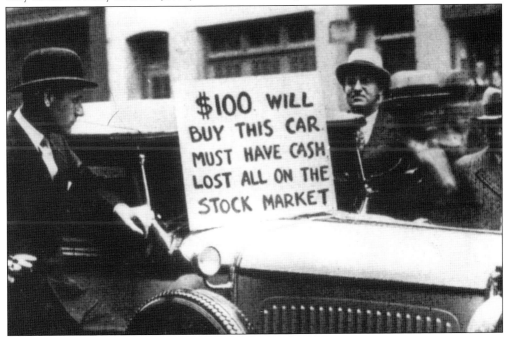

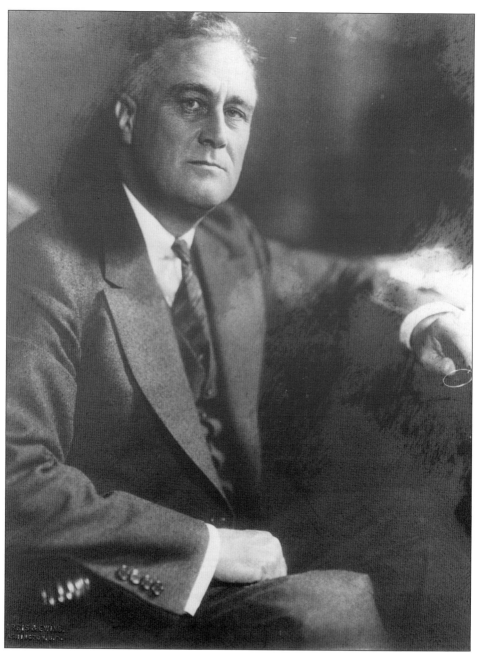

Despite the debilitating effects of infantile paralysis, otherwise known as polio, Roosevelt had America convinced he was the stronger man for the job of president. He was the first presidential candidate to campaign in an automobile, fly in a plane, and appoint a woman to his cabinet. He used the radio regularly to have "fireside chats" with the American people. Americans sat in front of radios and listened to FDR speak to them candidly about the country's problems and his plans for addressing them. He knit together a coalition of supporters from across the nation, and was swept into office in a huge victory over Herbert Hoover. He carried 42 of the 48 states. His New Deal was largely understood by Americans as government coming to the rescue of both the economy and social fabric of its citizens. (Courtesy of CCC Legacy.)

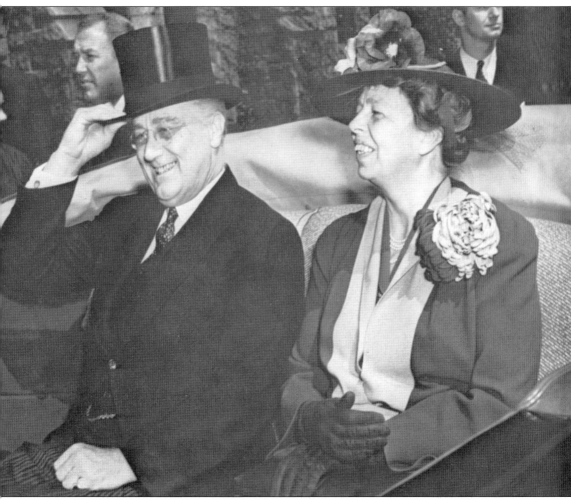

On March 4, 1933, Franklin Delano Roosevelt was inaugurated president of the United States. In his inaugural address he said, "This is preeminently the time to speak the truth, the whole truth frankly and boldly. Nor need we shrink from honestly facing conditions in our country today. This great Nation will endure as it has endured, will revive and will prosper. So, first of all, let me assert my firm belief that the only thing we have to fear is fear itself." Eight days later in one of his fireside chats he said, "The country needs and, unless I mistake its temper, the country demands bold, persistent experimentation. It is common sense to take a method and try it. If it fails, admit it frankly and try another. But above all, try something." (Courtesy of CCC Legacy.)

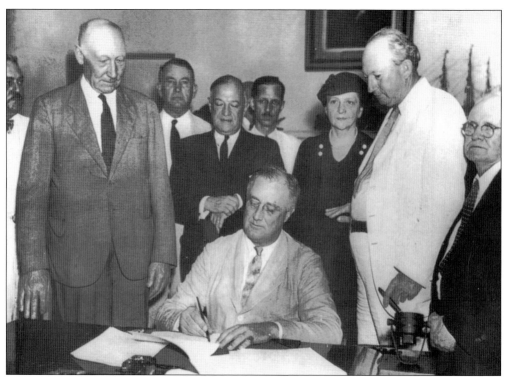

FDR wasted no time signing New Deal legislation and executive orders to get them functioning. Roosevelt declared a four-day bank holiday. Essentially, he shut down every bank in the country. The only money Americans had was what was in their pockets. He then called a special session of Congress and passed the Emergency Banking Relief Act. In his first week in office, FDR established two new communication approaches that persisted throughout his presidency: open press conferences and his famous fireside chats. Reporters were no longer required to submit questions in writing, which had been required by Hoover and Coolidge. So committed was he to an open relationship with the news media, that in 12 years, he had just two shy of 1,000 press conferences. (Both, courtesy of CCC Legacy.)

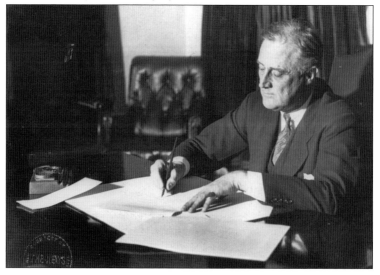

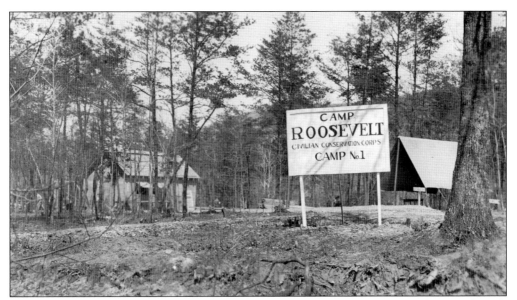

In a March 21 message to Congress, Roosevelt told them that if they gave him authority to launch the Civilian Conservation Corps, he would have camps open in a month. They gave him that authority on March 31. By April 17, Camp Roosevelt, the first CCC camp, was opened in Virginia. The New Deal program was off and running. Cartoonists poked fun at all the acronyms the army of bright young men and women Roosevelt had brought to Washington were inventing. The news media also took note of the support and action he was getting outside of Congress. This period became known as the "Hundred Days." (Both, courtesy of CCC Legacy.)

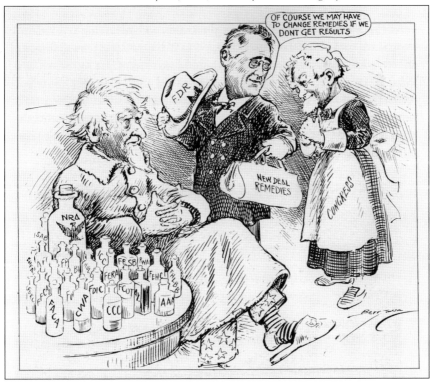

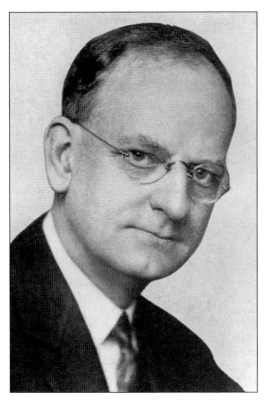

Two key players in FDR's New Deal were Robert Fechner (left), a longtime leader of the International Union of Machinists who was appointed director of the CCC, and Henry A. Wallace, who was appointed secretary of agriculture. The latter's father, Henry C. Wallace, had been secretary of agriculture from 1921 to 1924 for US presidents Warren G. Harding and Calvin Coolidge. Henry A. Wallace (at center below) was a progressive Republican and believed strongly in the New Deal. He was not the only Republican to serve in FDR's cabinet: Harold Ickes was appointed secretary of the interior and William Woodin secretary of the treasury. (Left, courtesy of CCC Legacy; below, courtesy of US Forest Service, Lee Ranger District.)

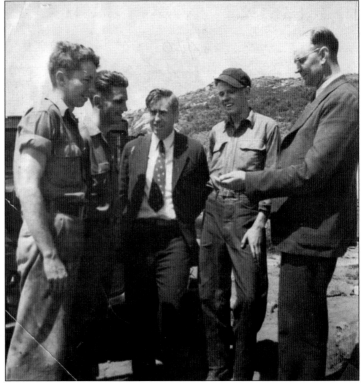

Harold Ickes would be called upon to marshal the resources of the Department of the Interior, and most importantly its National Park Service, to provide the technical expertise needed for the building of state and national park facilities in Virginia and across the country. (Courtesy of National Park Service History Collection.)

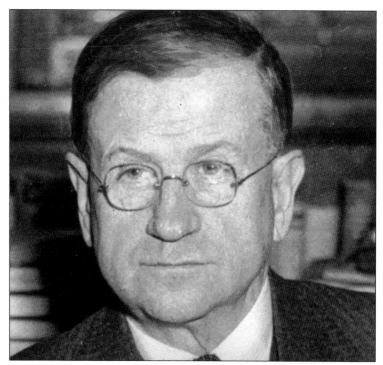

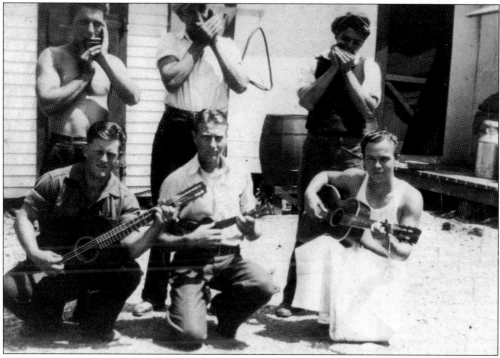

Perhaps demonstrating the whirlwind of the times, Henry Rich of Alexandria, Virginia, was the first enrollee in the Civilian Conservation Corps on April 7, 1933. He did not have a camp to report to until Camp Roosevelt opened on April 17, ten days later. Rich is the guitar player kneeling on the right. (Courtesy of CCC Legacy.)

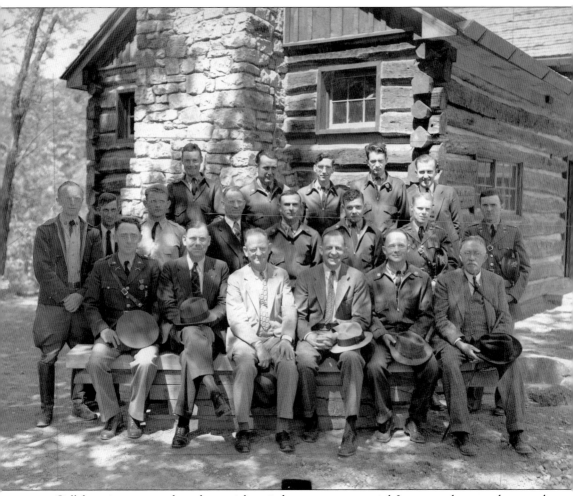

Collaboration, teamwork, and a special esprit de corps were essential. In a somewhat rare photograph showing representatives of the US Army and National Park Service personnel posing with CCC director Robert Fechner (center), that esprit de corps is on display. Roosevelt wanted a quarter million men in camps throughout the country by early summer, and it was going to take all the teamwork they had to make it happen. Fechner had dropped out of school at 16 to sell candy and newspapers. He got on as a machinist apprentice and eventually became a respected labor leader. He was known to say his clerks were better educated than he was. Conrad Wirth, deputy director of the National Park Service, said Fechner "knew little about conservation, but he was a good organizer and administrator." (Courtesy of US Forest Service, Lee Ranger District.)

Roads had to be built and equipment ordered to get Camp Roosevelt operational. The Army understood logistical challenges and provided the organizational expertise needed to move men and equipment to the front lines so "Roosevelt's Tree Army" could begin. While Camp Roosevelt was convenient for Washington dignitaries, it lacked good roads. What it lacked in access, it made up for in natural beauty and abundant resources needed to build the camps. Pictured above are men spreading stone by hand to build a base for a new road. Pictured below is a fleet of new Chevrolet trucks delivered to Camp Roosevelt. These new trucks, along with the road graders and bulldozers that would follow, made road building much easier and faster. (Above, courtesy of US Forest Service, Lee Ranger District; below, courtesy of National Park Service History Collection.)

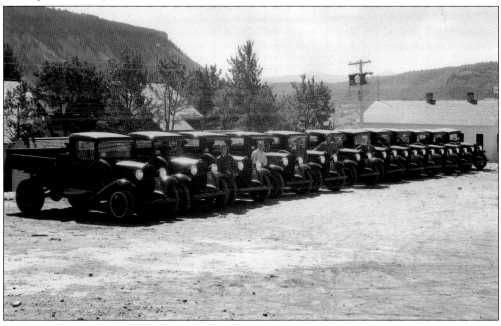

The first enrollees cleared land, pitched tents, and built the infrastructure needed to house, feed, and put to work hundreds of men according to US Army regulation. Trucks would pull out of camp in the morning with mealtime arriving out of the back of a canvas-covered truck. The CCC drew recruits from three main sources. First were the unmarried, unemployed 18-to-25-year-old boys whose families were on assistance. Then there were the out of work World War I veterans. Lastly were the Native Americans who were put to work on their reservations. (Both, courtesy of US Forest Service, Lee Ranger District.)

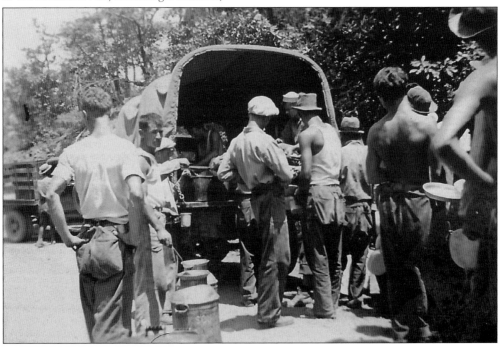

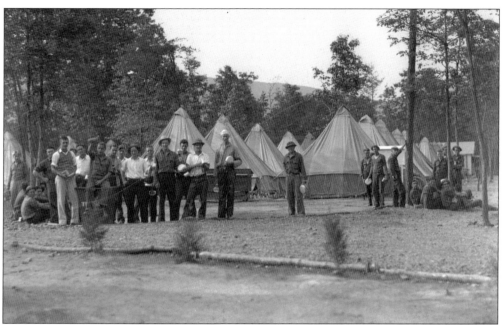

Housing and feeding the enrollees and staff were critical to morale and success. The Army's approach created order out of chaos and made recruits more comfortable in their primitive facilities. Three square meals a day were essential to the hard work and hot toil required of the new enrollees. Men earned about $30 a month, and $25 of that was sent home to help their families—though it was a small wage, it was considered a strong incentive to stick it out. As these photographs suggest, camp life fostered camaraderie. (Above, courtesy of CCC Legacy; below, courtesy of US Forest Service, Lee Ranger District.)

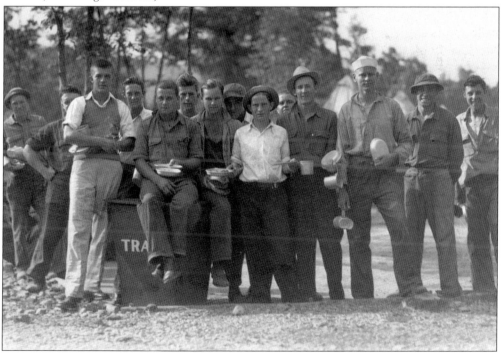

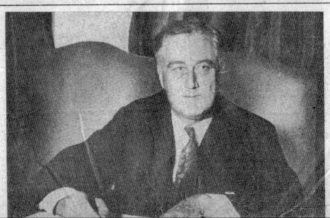

SMILES

Smiles come and go.
Grab them,
While they're smiles.
Now,
For Instance—

THERE is one forest worker at Camp Roosevelt, Va., who "can take it."

The bright lights of Edinburg, ten miles over the Massanutten mountain, lured him.

For the first two weeks, at least, so the story goes, this chap made that hike over the mountain each night after supper.

Capt. Leo Donovan, noticing the young man coming in after midnight, was curious. He spoke to him about it.

"Just been to town," the youth said.

"That's O. K. I don't care how often you go to town, so long as you're on the job the next day. But, tell me, how do you do it?" asked the captain.

"Oh, I can take it, all right, Captain," the new forest worker came back. "I hain't missed a morning yet and I work hard all day. Yes, Sir, I can take it all right."

As the youth moved on the captain observed:

"He sure can take it. Anybody who can swing a pick and shovel all day and then walk over that mountain to town and back each night to see a girl sure can take plenty of beating."

And ten miles over the mountain to the town means ten miles more back to the camp.

"Gee, I didn't know there were so many trees," said one of the

Happy Days

Authorized Weekly Newspaper of the Civilian Conservation Corps

SUBSCRIBE TO HAPPY DAYS! Six Months For ONE DOLLAR!

Vol. 1, No. 1 MAY 20, 1933 Five Cents Per Copy Three Cents In Camps

FOREST CAMPS TO BE FILLED BY JULY

Work For a Quarter of a Million Men

"WE are giving opportunity of employment to one-quarter of a million of the unemployed, especially the young men who have dependents, to go into the forestry and flood-prevention work. This great group of men have entered upon their work on a purely voluntary basis, with no military training and we are conserving not only our national resources but our human resources.

FRANKLIN D. ROOSEVELT

5,400 Men Will Move Into Work Camps Each Day

Rate of Movement to Be Greater Than That of Troops During War

Placing 275,000 workers in the forest camps by July 1 is the task confronting Robert Fechner, Director of the Emergency Conservation Work authorized by congress at the instigation of President Roosevelt.

Orders have gone out that the complete national quota of men for this employment in the national and state forests must be established in work camps by that date.

Beats War Record

It means that it will be necessary to enroll men at the rate of 8,540 per day and condition and install them in the work camps at the rate of 5,400 each day.

Such an average—receiving, processing an dequipping 8,540 men a day—is greater than that maintained by both the Army and Navy of the United States during the World war.

W. Frank Persons, of the department of labor, who is directing the selection of the men, has ordered each state to make its complete selection for the work by June 1 and complete their enrollment by

With a goal of keeping morale high and the camps informed on what was happening around the country, *Happy Days* was published as a weekly newspaper of the CCC. A six-month subscription cost $1. Pictured is Vol. 1, No. 1, the very first issue. This issue had FDR prominently pictured on page 1 above the fold. It demonstrates how popular the new president was and how his personal efforts were making the CCC a reality. He set targets that some thought impossible, but with determination and grit and a can-do spirit, he inspired the nation to go along with his New Deal. Roosevelt was determined to put 275,000 men into the camps by the summer of 1933, which would require approximately 3,000 new men moving into work camps each day. (Courtesy of CCC Legacy.)

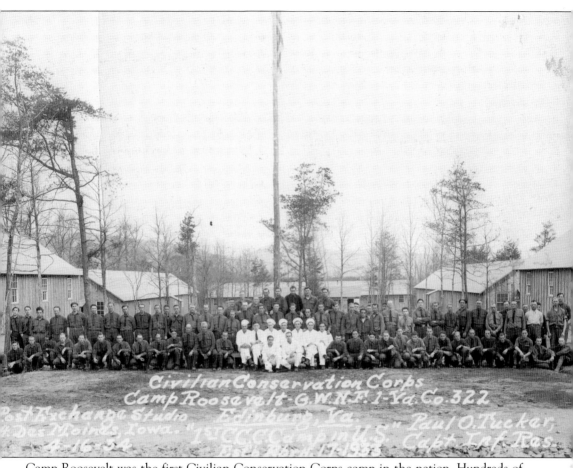

Camp Roosevelt was the first Civilian Conservation Corps camp in the nation. Hundreds of photographs were taken like this all across the country in the years from 1933 to 1942. Camp Roosevelt was where Roosevelt's Tree Army got its start. The US Forest Service designed their projects, and the National Park Service designed the projects for the nearby camps that worked on Shenandoah National Park. Over 300 Shenandoah National Park structures are listed in the National Register of Historic Places. These vary from architect-designed buildings such as Big Meadows and Massanutten Lodges, to bridges, stone-lined ditches, log comfort stations, and retaining walls. Camp Roosevelt was a testing ground for the new federal program and began to prove again that government can make a difference in people's lives and that of the nation. (Courtesy of CCC Legacy.)

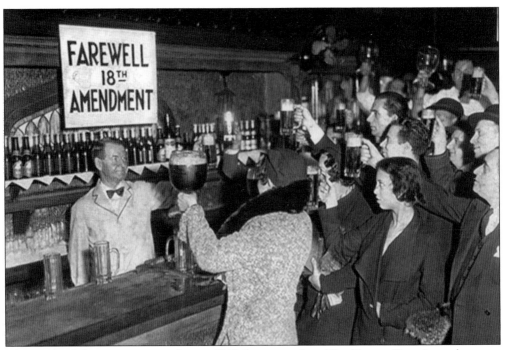

The winds of change were prevailing as 1933 drew to a close. The Twenty-First Amendment to the Constitution was passed and ratified, ending Prohibition on December 5, 1933. Now the government would be getting the taxes on alcohol sales, which before Prohibition amounted to about 14 percent of the local, state, and federal tax revenues. What had been an American tradition since Colonial days was now legal again. George Washington had distilled spirits at his gristmill near Mount Vernon, Virginia. His gristmill has been restored by the Commonwealth of Virginia and is again distilling using his original recipes. (Both, authors' collection.)

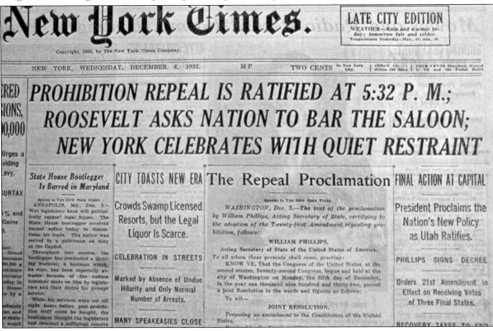

New York Times.

LATE CITY EDITION
WEATHER—Rain and warmer today; tomorrow fair and colder.
Temperatures Yesterday—Max, 51; min, 41.

Copyright, 1933, by The New York Times Company.

NEW YORK, WEDNESDAY, DECEMBER 6, 1933. M P. TWO CENTS

PROHIBITION REPEAL IS RATIFIED AT 5:32 P. M.; ROOSEVELT ASKS NATION TO BAR THE SALOON; NEW YORK CELEBRATES WITH QUIET RESTRAINT

State House Bootlegger Is Barred in Maryland

ANNAPOLIS, Md., Dec. 5.— Wet legislators here will patriotically support legal liquor. The State House bootlegger received formal notice today to discontinue his trade. The notice was served by a policeman on duty at the Capitol.

Throughout this session, the bootlegger has conducted a thriving business; a business which, he says, has been especially attractive because of the sudden demands made on him by legislators and their desire for prompt service.

While his services were cut off eight hours before post-prohibition stuff could be bought, the bootlegger thought the legislators had obtained a sufficient reserve

CITY TOASTS NEW ERA

Crowds Swamp Licensed Resorts, but the Legal Liquor Is Scarce.

CELEBRATION IN STREETS

Marked by Absence of Undue Hilarity and Only Normal Number of Arrests.

MANY SPEAKEASIES CLOSE

The Repeal Proclamation

Special to The New York Times.
WASHINGTON, Dec. 5.—The text of the proclamation by William Phillips, Acting Secretary of State, certifying to the adoption of the Twenty-first Amendment repealing prohibition, follows:

WILLIAM PHILLIPS,
Acting Secretary of State of the United States of America.
To all whom these presents shall come, greeting:
KNOW YE, That the Congress of the United States, at the second session, Seventy-second Congress, begun and held at the city of Washington on Monday, the fifth day of December, in the year one thousand nine hundred and thirty-two, passed a joint Resolution in the words and figures as follows:
To wit—
JOINT RESOLUTION.
Proposing an amendment to the Constitution of the United States.

FINAL ACTION AT CAPITAL

President Proclaims the Nation's New Policy as Utah Ratifies.

PHILLIPS SIGNS DECREE

Orders 21st Amendment in Effect on Receiving Votes of Three Final States.

RECOVERY TAXES TO END

Three

BATTLEFIELDS, FORESTS, PARKS, AND PARKWAYS

Millions of trees were planted and modern conservation practices were employed in the George Washington National Forest, and the George Washington, Colonial, and Blue Ridge Parkways made travel by car not only convenient, but also stimulated a whole new recreational pursuit—driving for pleasure.

Prince William Forest Park was designed to introduce inner-city youth to the awe and wonder of the great outdoors. It provided a large, expansive park of 15,000 acres in close proximity to the nation's capital and the expanding suburbs of Northern Virginia that were home to many who worked with or for the federal government.

Civil War battlefields that had laid dormant with little stewardship or programming while under military control were moved to the National Park Service, which could better tell the story of division, war, and reconciliation to millions of visitors annually at battlefields in Appomattox, Richmond, Petersburg, Fredericksburg, Manassas, and others across the state.

More important than the construction of new roads and rehabilitation of forests and parks that showcased their natural, cultural, and recreational treasures was the impact this work had on the hearts and minds of the boys. They learned new skills, gained confidence in their ability to work with others on work that was meaningful, improved their physical and mental health, and were prideful of their ability to help their families and their nation. Roosevelt had demonstrated that government could transform the nation, build its way out of the Depression, and imagine a brighter future.

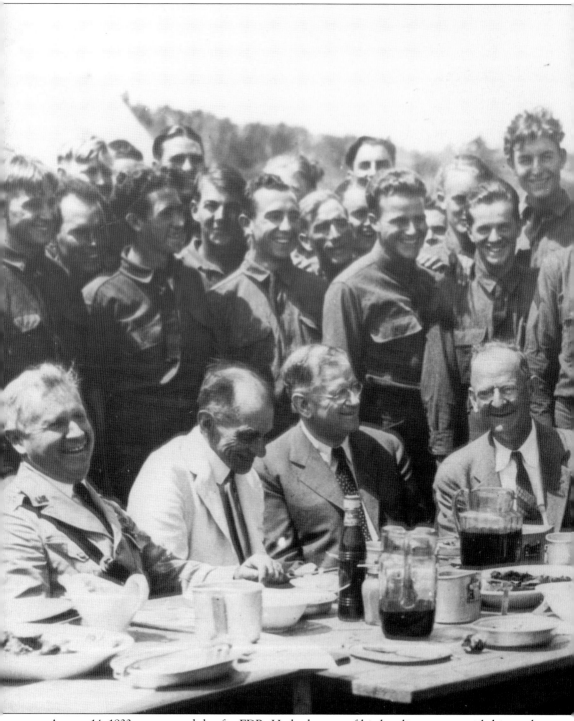

August 14, 1933, was a good day for FDR. He had many of his key lieutenants with him as he toured Camp Roosevelt and the work at America's first CCC camp. Three senior members of his administration, the Department of Agriculture's Henry Wallace (to FDR's left), CCC director Robert Fechner, and the Department of the Interior's Harold Ickes (to his right), joined him for

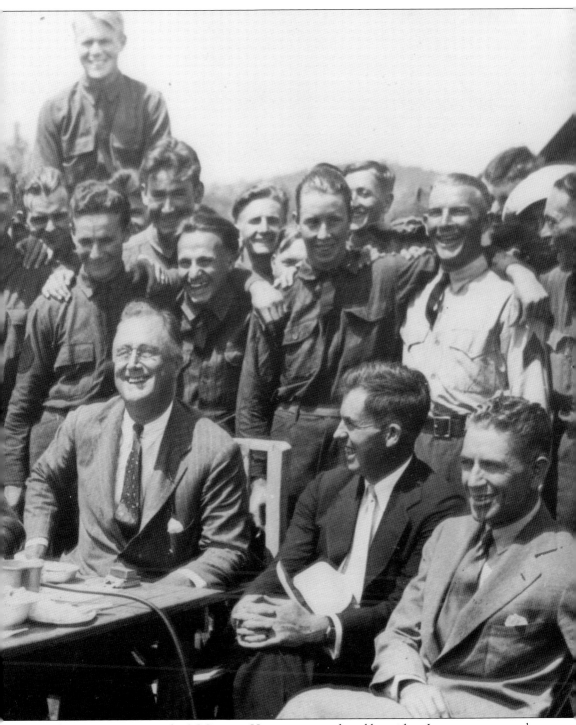

this first inspection tour of a CCC camp. He was impressed, and he said so. In a report captured on film by Universal News, FDR said he hoped all the camps would be in as fine a condition as what he saw today. He also remarked that the boys had gained 12 pounds on average since they arrived on April 17, not quite four months earlier. (Courtesy of CCC Legacy.)

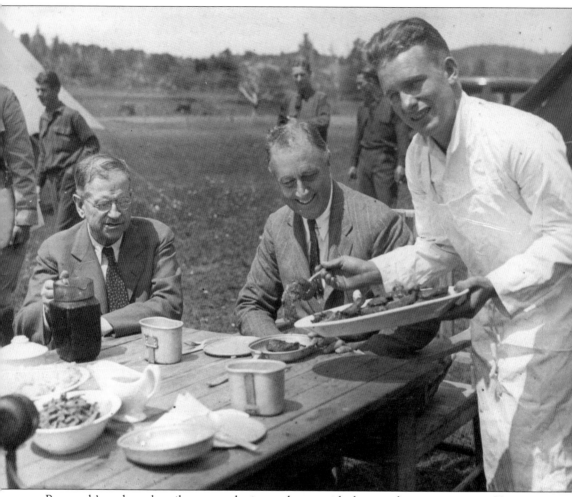

Roosevelt's trademark smile suggests he is very happy with the way things are going in Virginia. Success in Virginia was important to not only the state, but also the nation. There was going to be a lot of work done if the New Deal proved itself. In addition to Shenandoah National Park, work would be done on Colonial National Park, Prince William Forest Park, the Blue Ridge Parkway, George Washington Parkway, and the Colonial Parkway. Virginia's national battlefields were in dire need of preservation. Those targeted by the CCC included Yorktown, Fredericksburg, Petersburg, Wilderness, Richmond, and Appomattox, to name a few. Despite the momentous project at hand, later that day, on August 14, 1933, FDR was persuaded by William Carson to put camps to work building state parks in Virginia. (Courtesy of US Forest Service, Lee Ranger District.)

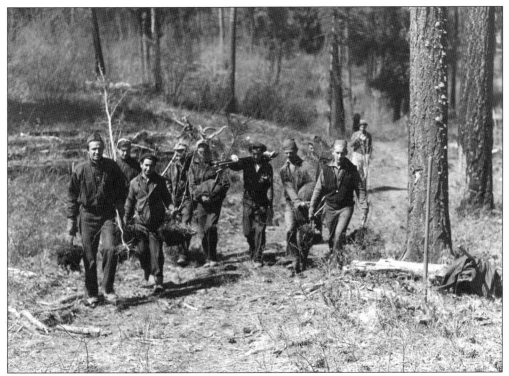

Shenandoah National Park, at more than 176,000 acres, was the largest national or state park project, acreage wise, in Virginia. The eight Shenandoah camps were occupied nearly full time during the CCC's existence. The use of a pick, shovel, mattock, and popular Pulaski hand tool built a strong corps. (Courtesy of National Park Service History Collection.)

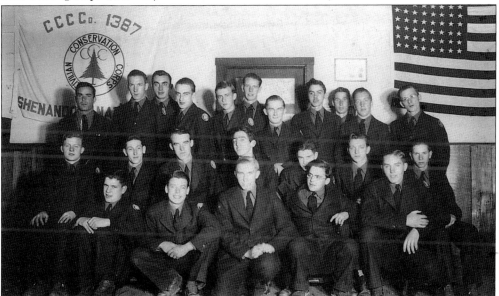

The note on the back of this photograph reads, "Pittsburgh Rookies, 1939–1940." The Pennsylvania boys of CCC Company No. 1387, stationed at NP-3, Skyline Drive in Elkton, Virginia, proudly pose with their company flag and the US flag. (Courtesy of US Forest Service, Lee Ranger District.)

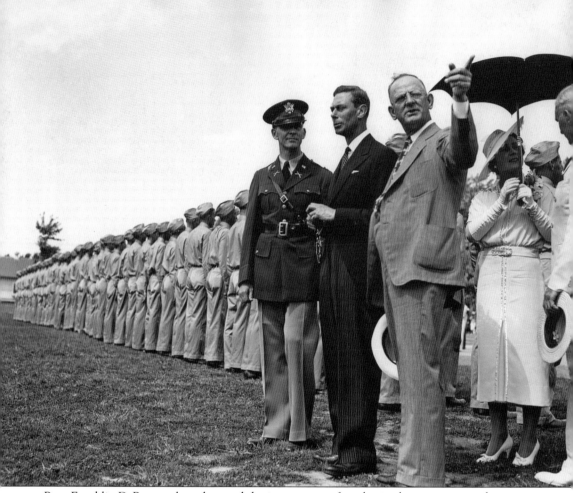

Pres. Franklin D. Roosevelt understood the importance of marketing his programs to the nation. England's King George VI and Queen Elizabeth visited Fort Hunt on June 9, 1939, to inspect the work being done by the Civilian Conservation Corps and to review the military personnel. CCC director Robert Fechner seems to have lost the King's attention to an Army officer. The Royal visit came at the invitation of President Roosevelt, who was keen to demonstrate kinship with the English as war drums were beating in Europe and the Germans were invading Poland. Their visit was also a way to show that other heads of state admired his CCC program. A day earlier, the president greeted the royals as they arrived at Union Station in Washington, DC. (Courtesy of CCC Legacy.)

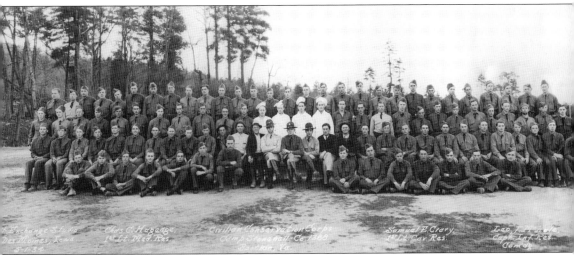

The camp at Bastian, Virginia, in Bland County seemed to have trouble settling on its name. When the 212 men arrived by Norfolk Western Railway from their training camp at Fort Lee, Virginia, they were surprised to find there were no campsite buildings and no barracks with comfortable cots, as they had expected. They found that they were there to build everything from scratch. The men of Company No. 1388 arrived on June 4, 1933, and had four months before the snow season arrived. Their camp was called Camp Wyatt. Later, it became Camp Cherokee, and by the time this photograph was taken on May 1, 1934, Company No. 1388 was living at Camp Stonewall. Capt. Leo J. McHale was the company commander, and his lieutenants were Charles Hagadge and Samuel Crary. By December, 20 buildings, including six barracks capable of housing up to 50 men each, were constructed with help from local men. (Courtesy of Bland County Historical Society.)

The Chopawamsic Recreational Demonstration Area later became Prince William Forest Park. The enrollees were housed in the familiar Army tents until the camp's wooden barracks, mess hall, and other supporting structures were built. Virginia had one other recreation demonstration area (RDA) called Swift Creek, now known as Pocahontas State Park. More than 2,000 CCC enrollees worked the land along the Chopawamsic and Quantico Creeks. It was one of 46 such land-use projects spread across the nation. The RDA was designed to be a place where low-income, inner-city children and families could get away and experience the outdoors. Eighty years later, children are still using Prince William Forest as park planners had hoped. This park is said to have more, and among the best preserved, CCC structures than any other park in America. (Both, courtesy of National Park Service Archives, Prince William Forest.)

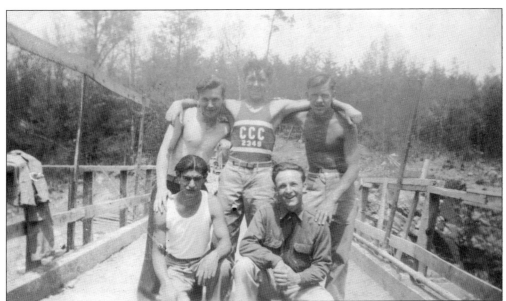

Hard work was the order of the day, but the enrollees did take time to have fun. A basketball player is seen above wearing his CCC Company No. 2349 jersey. Shirtless Edward James Smith is standing at back right. He was born on January 14, 1920, and served Company No. 2349 (1935–1937), as written on the back of the photograph. He also served in Idaho and New York. He enlisted in the Navy after Pearl Harbor and became a chief petty officer. At right, several daredevils of Company No. 2349 have climbed the water tower for a picture. Finding a good source of water, capturing it, and holding it for the camp's use was one of the first and most important things for the camp to function. (Both, courtesy of National Park Service Archives, Prince William Forest.)

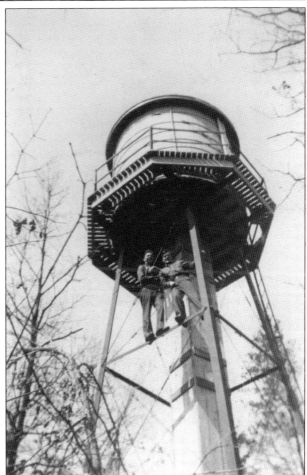

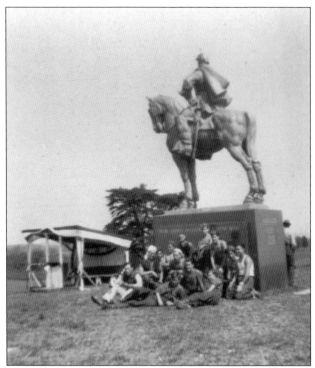

The first major battle of the Civil War took place on July 21, 1861, in Prince William County, 25 miles from Washington, DC. It was called the Battle of Bull Run by the United States and Battle of First Manassas by the Confederate States of America. Work by CCC Company No. 2349 on the battlefield included preparations for dedication of the statue of Confederate general Thomas "Stonewall" Jackson. Supervisor "Hattie" Dawson and the boys prepared the statue for its official unveiling. At the battle, Jackson was given the nickname "Stonewall" for leading a brigade of Virginians in holding their ground. After completing their work, the CCC troops posed with one of the battlefield's cannons. (Both, courtesy of National Park Service Archives, Prince William Forest.)

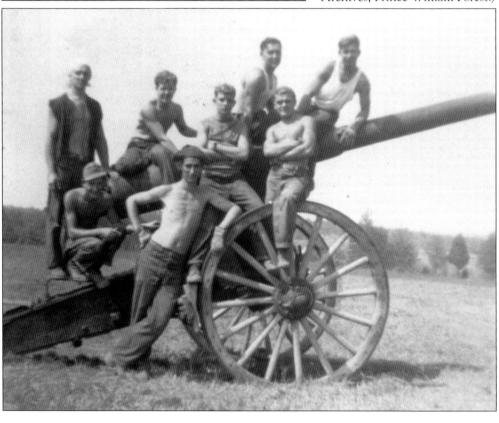

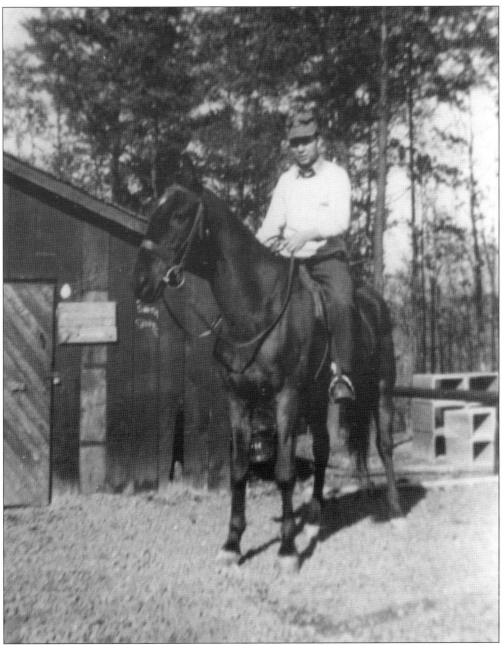

"Exercising Company Commander's Horse" is the caption on this photograph. The company commander would have used his steed to check on his company and their work. It would have participated in formal ceremonies and been used throughout the camps on a variety of tasks, especially when poor roads and challenging terrain demanded their use. The Army had used horses extensively through World War I and opened its East Coast Remount Depot in the mountains near Front Royal, Virginia, in 1911 to serve the cavalry. Two of Gen. John "Blackjack" Pershing's horses are buried there. Today, the Smithsonian owns the property and operates its Conservation Biology Institute, which serves the animals at the National Zoo in Washington, DC. (Courtesy of National Park Service Archives, Prince William Forest.)

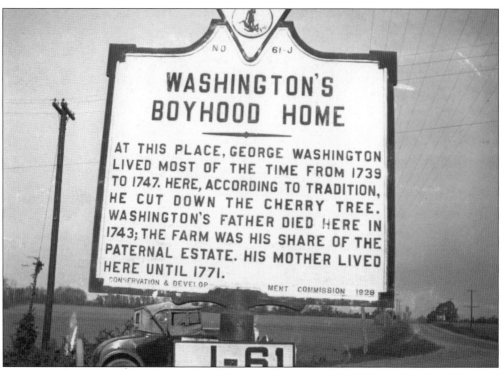

WASHINGTON'S BOYHOOD HOME

NO 61-J

AT THIS PLACE, GEORGE WASHINGTON LIVED MOST OF THE TIME FROM 1739 TO 1747. HERE, ACCORDING TO TRADITION, HE CUT DOWN THE CHERRY TREE. WASHINGTON'S FATHER DIED HERE IN 1743; THE FARM WAS HIS SHARE OF THE PATERNAL ESTATE. HIS MOTHER LIVED HERE UNTIL 1771.

CONSERVATION & DEVELOP- MENT COMMISSION 1929

The Virginia State Conservation and Development Commission chairman William Carson launched a highway historical marker program in 1927 to promote the commonwealth's historic sites. George Washington Birthplace National Monument, located where Pope's Creek meets the Potomac River on Virginia's historic Northern Neck, benefitted from work done by Camp Stratford, Company No. 2352. The camp was located several miles away in Baynesville. The monument to the nation's famous Revolutionary War general and first president was moved to its present site by Company No. 2352 and is a 1/10 scale replica of the George Washington Monument on the National Mall in Washington, DC. (Above, courtesy of Virginia State Parks; left, authors' collection.)

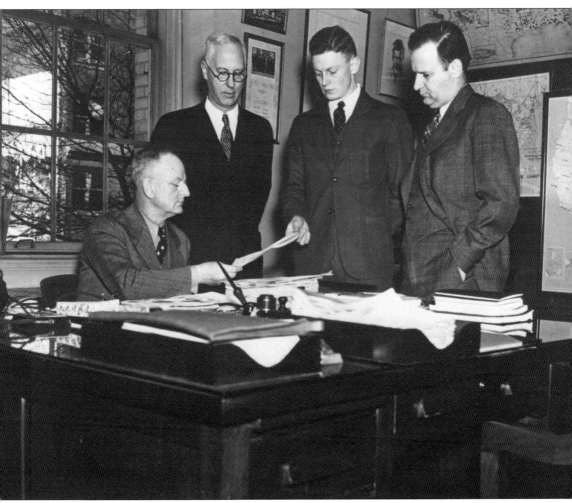

On March 3, 1937, twenty-two-year-old Elbert Jackson Lester, a native of East Radford, Virginia, became the first CCC enrollee in the civil service. He is pictured with CCC director Robert Fechner (seated); Fred Morrel, assistant chief of emergency conservation work for the Department of Agriculture (on Fechner's left); and Conrad Wirth (far right), assistant director of the National Park Service (NPS). Lester was assigned to Camp Roosevelt as a junior assistant technician. Conrad Wirth was educated as a landscape architect and joined the NPS in 1931 as a member of the National Capitol Park and Planning Commission staff. He supervised the Civilian Conservation Corps in the state parks. He was appointed director of the NPS in 1951 and submitted his resignation letter to President Kennedy in 1963 and served until 1964. (Courtesy of National Park Service History Collection.)

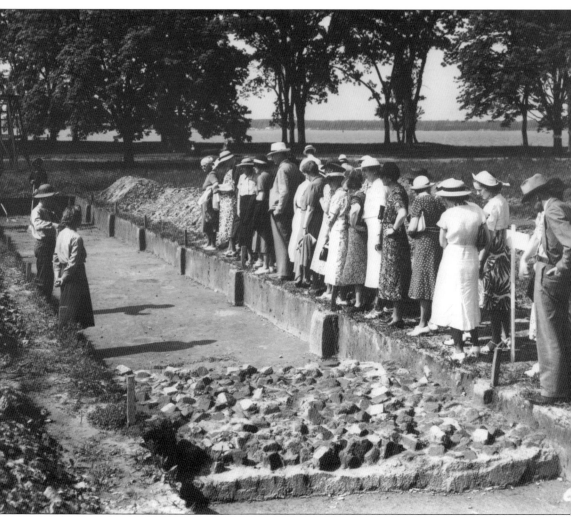

Colonial National Monument was authorized on July 3, 1930, and established on December 30, 1930. It was re-designated Colonial National Historical Park on June 5, 1933. The park is in the Hampton Roads region of Virginia and encompasses the settlement of Jamestown, founded in 1607, and Yorktown Battlefield, where the British army surrendered in the American Revolutionary War. The Jamestown National Historic Site is co-owned by the National Park Service and Preservation Virginia, formerly called the Association for the Preservation of Virginia Antiquities. Preservation Virginia owns 22 acres that contain the remains of the original fort, and the National Park Service owns the remaining 1,178 acres of the island that contain archeological remains. In this photograph, men and women learn about the buildings and artifacts found during research; the James River is in the background. (Courtesy of National Park Service History Collection.)

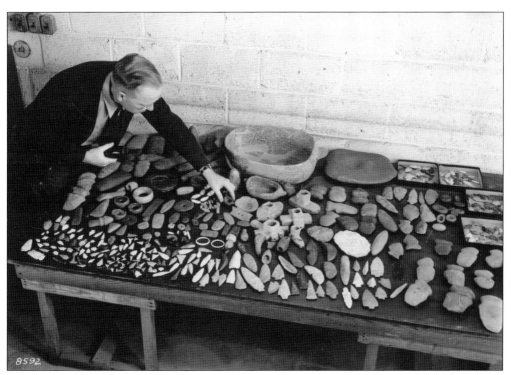

Artifacts from the Preservation Virginia site at Jamestown include findings from when Capt. John Smith and members of the Virginia Company met Chief Powhatan of the Powhatan Confederation and his daughter Pocahontas. Displayed in the photograph above are Native American artifacts, including stone arrowheads and spear points. Associate archaeologist J.C. Harrington is examining the Wirt Robinson Collection of Virginia Indian Artifacts that had been acquired for an exhibit at Jamestown on December 13, 1940. Many of these artifacts are older than the colony itself. In the photograph at right, the pottery was labeled "Sgraffite ware from Jamestown 3 March 1942." The CCC helped dig, wash, sort, and catalogue more than 500,000 artifacts at Jamestown. (Both, courtesy of National Park Service History Collection.)

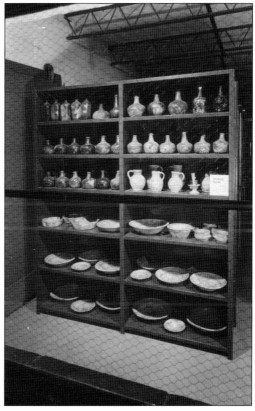

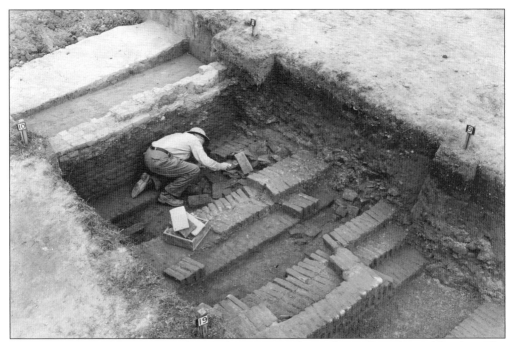

The archaeology work was painstakingly done using undersized trowels, picks, and brushes. The treasures unearthed at Jamestown have helped historians and scientists recreate the story of the first permanent English-speaking colony in North America. The back of this photograph reads, "Associate Archaeologist J. C. Harrington is removing a partially burned roofing tile from early brick kiln uncovered in the Beverley tract in the APVA Grounds. September 11, 1941." In the photograph below, dated October 7, 1955, the work that had been started by the CCC from 1933 to 1942 was begun again after World War II. (Both, courtesy of National Park Service History Collection.)

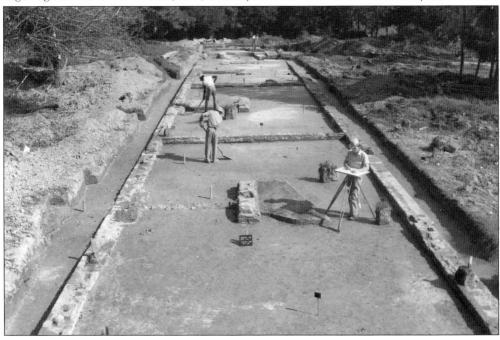

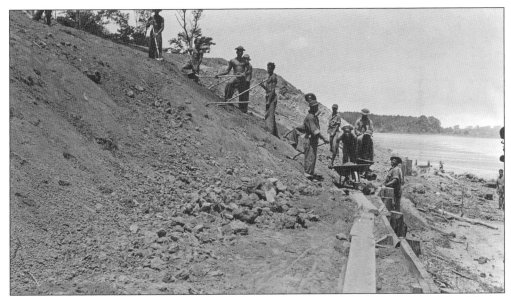

CCC camps were segregated; scattered throughout the nation were 150 camps for African Americans. Of the three million young men enrolled in the CCC, 250,000 of them were African American. FDR wrote the following to CCC director Robert Fechner on September 27, 1935: "In the CCC Camps, where the boys are colored, please try to put in colored foremen, not of course in technical work but in the ordinary manual work." (Courtesy of National Park Service History Collection.)

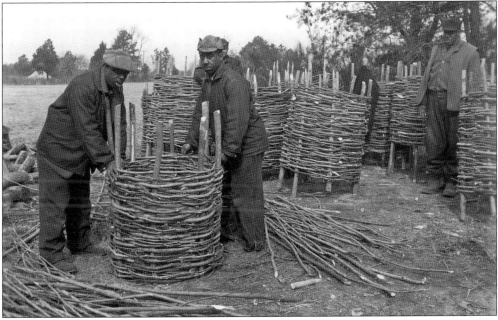

African American enrollees built bulkheads and installed landscaping at Jamestown Island to prevent erosion of the historic site. African Americans are pictured building gabion baskets that were filled with rocks and used in the reconstruction of the fortifications at Yorktown. A note on the back of this photograph reads, "Gabions being built for reconstruction of the French Battery, 1935." (Courtesy of National Park Service History Collection.)

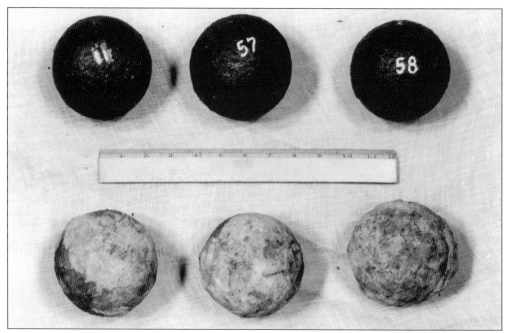

Cannonballs were among the artifacts discovered in the York River. The balls on the bottom row are shown as they appeared when pulled from the riverbed. The top row is after they were treated for preservation. The ruler helps the viewer to understand the size of these balls. They appear to be about four inches wide. (Courtesy of National Park Service History Collection.)

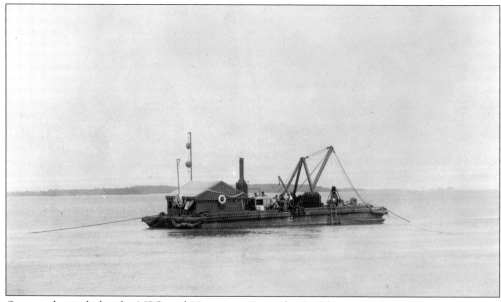

Operated jointly by the NPS and Newport News Shipbuilding, this barge was used in the salvage process that recovered the cannonballs. Fort Monroe, or Old Point Comfort, guarded the navigation channel between the Chesapeake Bay and Hampton Roads. During the initial exploration by Capt. Christopher Newport, it was identified as a strategic defensive location, and in 1609, defensive fortifications were built at Old Point Comfort. (Courtesy of National Park Service History Collection.)

Congress formally established the Blue Ridge Parkway on June 30, 1936. In March 1937, Stanley Abbott, a 25-year-old landscape architect from Cornell University, was named resident landscape architect and acting superintendent of the Blue Ridge Parkway. He came with experience on the Bronx River Parkway and the Westchester County (New York) Park Commission. He was an admirer of Frederick Law Olmsted, who designed New York's Central Park and the landscape at the Biltmore Estate in North Carolina. Like Olmsted, Abbott was of the "design with nature" school of road construction. His son Carlton, an accomplished park architect in his own right, was fond of quoting his father's belief that a parkway should "lie easily on the ground." Abbott wanted the parkway to be an outdoor museum. His bridges would hide the modern life nearby and allow visitors to become immersed in the natural setting. (Both, authors' collection.)

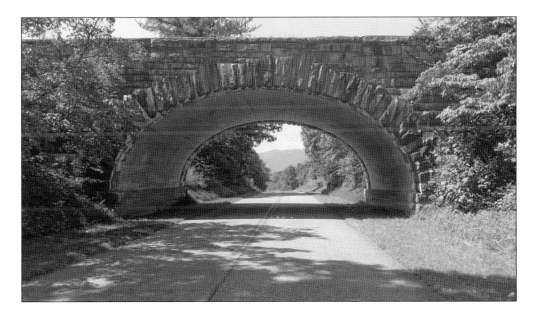

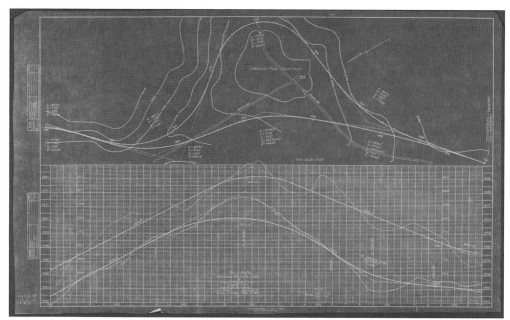

The schematic drawing above was used in the design of the Lost Mountain and Poor Mountain Overlooks on the parkway in the Roanoke area. It demonstrates the care that was taken to make sure that the overlook would not only provide a safe pull off for automobiles, but would also focus attention on the vista. Stanley Abbott's desire was to create an opportunity to enjoy the natural landscape while learning about its significance. Below, CCC enrollees are hard at work on an overlook's parking bumpers. (Above, courtesy of Open Parks Network; below, courtesy of National Park Service History Collection.)

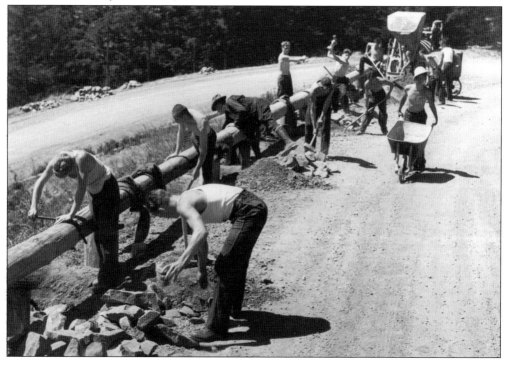

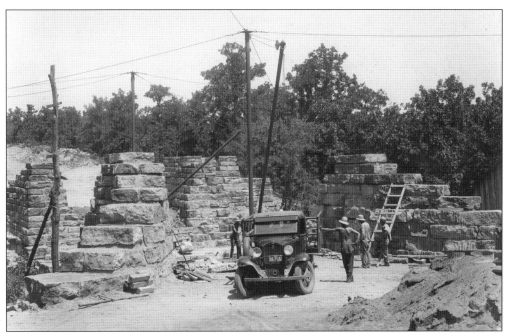

Bridges would carry parkway traffic over streams, valleys, and roadways or allow a roadway with commercial vehicles to pass over the parkway. Stanley Abbott's design concept was to make the traveler feel as though they had left behind the daily grind. The parkway experience would be leisurely, without visual clutter. Parkway bridges featured cut stone that would blend into the environment. Stone masons had precise engineered drawings to work from and, thanks to the enrollees, an abundance of labor and equipment to move heavy pieces of granite. (Above, courtesy of National Park Service History Collection; below, courtesy of Open Parks Network.)

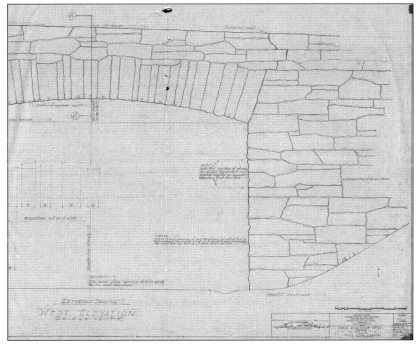

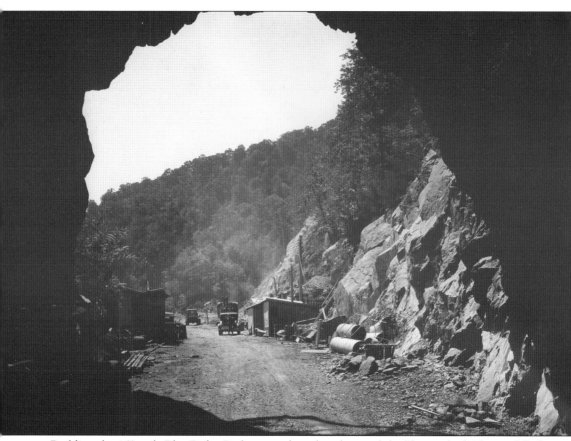

Building the 469-mile Blue Ridge Parkway anchored in the north by Shenandoah National Park and in the south by Great Smoky Mountain National Park put highway engineers and architects to the test. In some cases, a bridge made of granite was called for, and in other cases, a tunnel had to be carved through solid granite. Pictured is the south end of Mary's Rock Tunnel during its construction. Mary's Rock Tunnel is 610 feet long. Constructed in 1932, it is considered one of the engineering feats of the Skyline Drive. It took three months of constant drilling, blasting, and clearing to complete the tunnel. Twice each day, workers drilled 40 holes, each 12 feet deep, into the tunnel's rock face. A total of 500 pounds of dynamite filled the holes and was then detonated. (Courtesy of National Park Service History Collection.)

Austin Powder has been making explosives since 1833. Founded in Akron, Ohio, along the banks of the Cuyahoga River, they produced Red Diamond dynamite, which was used on the Mary's Rock Tunnel and on other projects that required explosives. A local newspaper described the process undertaken to carve the tunnel through Mary's Rock: "After the blast goes off with a mighty roar it requires two or three hours to clear away the loose boulders and stone and to roll them over the side . . . three 8-hour shifts of about 15 men each are on duty . . . the machinery never being idle except on Sunday . . . every day 15 or more feet of solid rock are eaten away by the blasts." Pictured at right, a hand-held air drill is being used to drill the holes that would be filled with dynamite. (Both, courtesy of National Park Service History Collection.)

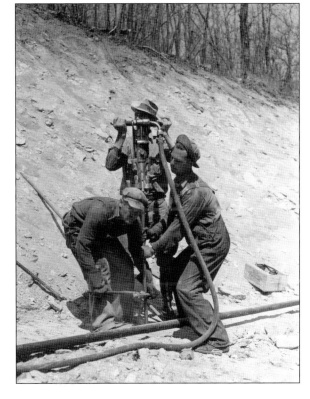

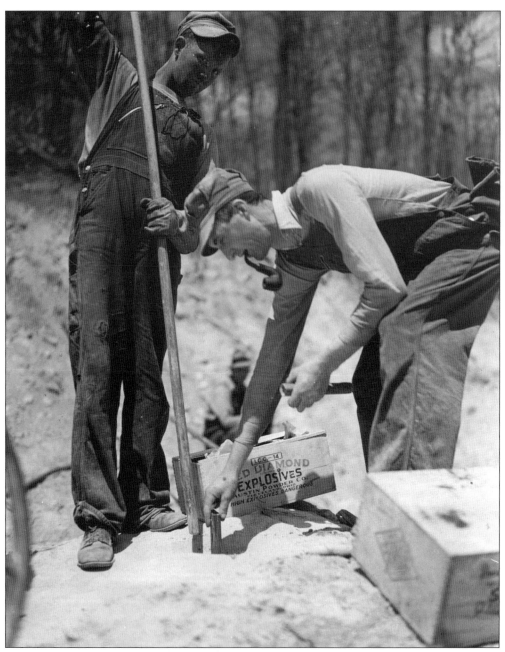

From this picture, it would appear that nothing in the way of safety equipment was required when engaged in blasting. In this photograph at Mary's Rock, the hole has been drilled and is being filled with dynamite. It would have then been tamped down with a steel bar. Not uncommon was for a CCC worker to take his burning pipe and light the fuse. Accidents did occur, but seldom recorded as a matter of record. A long fuse and fast feet were required to get out of harm's way. At completion, the tunnel required 80 blasts a day, six days a week, for three months. In all, 21,600 blasts were necessary. This did not include unsuccessful firings. (Courtesy of National Park Service History Collection.)

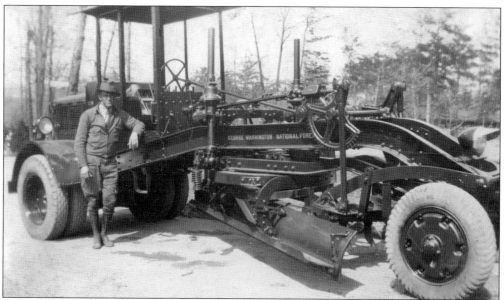

The CCC road construction totaled 109 miles of Skyline Drive and 469 miles of Blue Ridge Parkway. Many more miles of roadway within state and national parks, battlefields, and in the national forests of Virginia were built. Bulldozers and road graders were essential to the kind of progress FDR expected. In the photograph above, "George Washington National Forest" is painted on the grader. The CCC boys learned to make many things from raw materials. Below, they are making roof shingles. These were split from trunks of cedar, fir, or other straight-grained timber. The basic equipment required was a crosscut saw to cut the sections to 18 to 24 inches. Wooden shingles were a popular product in the 1930s because of the readily available resource. (Above, courtesy of US Forest Service, Lee Ranger District; below, courtesy of National Park Service History Collection.)

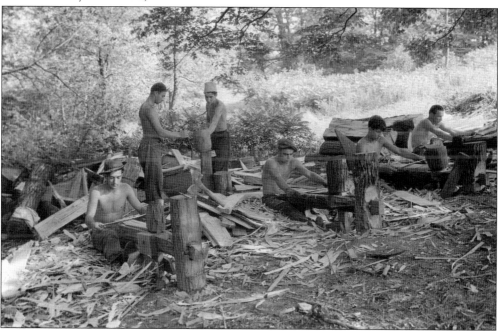

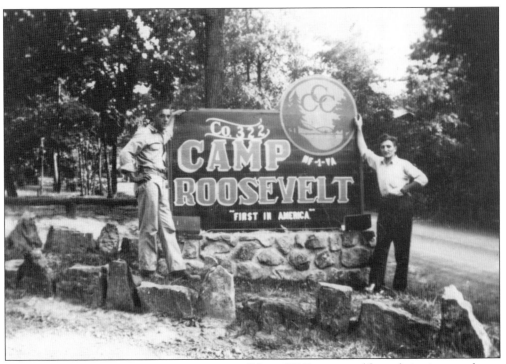

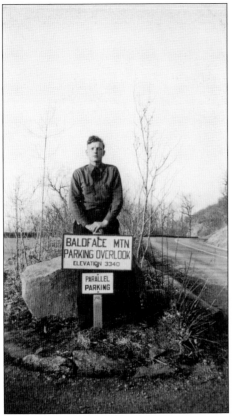

Often, CCC men would get their picture taken with the sign of the project they worked on. Many enrollees took their picture with the "Camp Roosevelt 'First in America' " sign since it is where the CCC was born. Pictured at left is Maurice Brooks on the Baldface Mountain Overlook. He wrote on the back of this picture that his company worked on Skyline Drive in "their section of the trail." The overlook is at mile marker 61.8 on the Skyline Drive at an elevation of 3,345 feet. The views are great, and the lookout is only about a half mile from where a CCC camp and a rock quarry were located. (Both, courtesy of CCC Legacy.)

In 1933, First Lady Eleanor Roosevelt succeeded in getting camps for jobless women authorized and funded by presidential order. She had the support of Labor Secretary Frances Perkins. Under Perkins's leadership, the Department of Labor played a major role in the design of the CCC and selection of its enrollees. The women's version of the conservation corps (known as the She-She-She) was very modest and overall served only about 8,500 women. In all probability, it would not have existed at all without Eleanor Roosevelt and Frances Perkins's drive to make it happen. Perkins served as secretary of the Department of Labor from 1933 to 1945—the longest anyone had served in the position in history and tied with Roosevelt's Secretary of Interior Harold Ickes for the longest-serving cabinet member in history. Both served throughout FDR's entire presidency. Perkins was also a pioneer, being the first woman in the cabinet, and as such, the first woman in the line of succession to replace the president if necessary. Currently, the secretary of labor is 11th in line to succeed the president. The She-She-She program was an important victory for women. (Both, courtesy of CCC Legacy.)

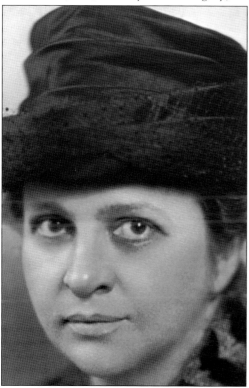

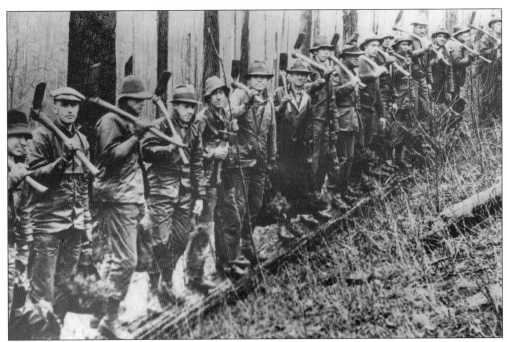

Roosevelt's Tree Army began its effort to plant three billion trees around the country near the towns of Luray and Edinburg on April 17, 1933. More than 180 CCC camps operated in Virginia over the next nine years. They planted about 15.2 million trees in Virginia alone and three billion across the nation. By the end in 1942, $109 million was spent on the CCC in Virginia, and the men built almost 1,000 bridges, stocked 1.3 million fish, and strung more than 2,100 miles of telephone line. They built Shenandoah National Park and the Blue Ridge Parkway. On June 15, 1936, six CCC-built Virginia State Parks opened. Seen below, the boys are marching to the dedication of Shenandoah National Park on July 3, 1936. President Roosevelt spoke to them that day and said, "We seek to pass on to our children a richer land—a stronger nation. I, therefore, dedicate Shenandoah National Park to this and succeeding generations of Americans for the recreation and for the re-creation which we shall find here." (Above, courtesy of National Park Service History Collection; below, courtesy of CCC Legacy.)

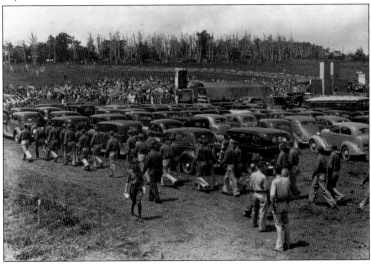

Four

THE BIRTHING
OF STATE PARKS

National Park Service director Stephen T. Mather knew the national park idea was a good one, but not an all-encompassing one. There were some ideas that needed to be left to the states. In 1921, Mather hosted the first ever national conference on parks in Des Moines, Iowa. At that conference and in those he hosted every year until his death in 1930, Mather refined the idea of what distinguished national parks from state parks. He believed the most iconic of the nation's places—places like Yosemite, Yellowstone, Grand Teton, Crater Lake, and other great parks of the West and places like the Acadia, Shenandoah, Great Smoky Mountain, and Everglades in the East—were iconic natural treasures. Independence Hall, Jamestown, Yorktown, and Appomattox Courthouse, these were among the iconic cultural treasures.

State parks would be those state significant natural, cultural, and recreational treasures. States, in Mather's view, should buffer the national parks from every congressman's desire to have a national park in their backyard.

Virginia governors John Garland Pollard, Harry F. Byrd, and George C. Peery all supported development of a state park system. Finding the resources to acquire, design, and build state parks was always the hard part. Nurturing the state park idea since the mid-1920s was William Carson. He had proved his commitment and dedication to the cause by negotiating with the federal government the development of Shenandoah National Park if Virginia would buy the land for the project. He had also tasked R.E. Burson, a landscape architect, with visiting other state parks around the country and determining how a model park system should be developed. Like Mather, Carson saw state parks as places people would drive to for outdoor recreation, quiet solitude in nature, and to learn about history. They believed they would visit often if the parks were relatively "close to home."

No one deserves more credit for bringing Virginia's state parks to life than William Carson and Harry Byrd. Byrd ran for governor in 1925 on a platform that included capitalizing on the state's natural and cultural assets. Carson (left) was a close friend of Byrd and had served as best man to Harry Byrd's brother, Rear Adm. Richard Evelyn Byrd, a famous explorer. Carson ran his family's lime quarry in Riverton, Virginia, near Front Royal on the Shenandoah River. Carson was Byrd's campaign manager, and after Byrd took office on February 1, 1926, Carson was appointed chairman of the newly created Conservation and Development Commission. (Both, courtesy of Virginia State Parks.)

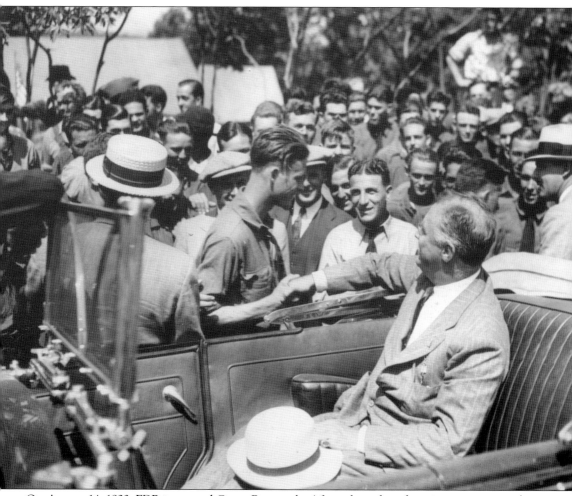

On August 14, 1933, FDR inspected Camp Roosevelt. After a long day of touring, meeting, and lunching with the enrollees, he spent time at Hoover's presidential retreat. Joining FDR at the camp was William Carson. In an account captured by the publicist for the Conservation and Development Commission, FDR asked Carson what he thought of the work the boys were doing. Carson said he thought it was fine, but the president would leave a more lasting legacy to the nation if he put the boys to work on building state parks that would become vacation venues for the working man, who could not afford the more deluxe resorts. Roosevelt thought about it and said, "If I give you the money and manpower to build a model park system, can Virginia provide the land?" Carson said, "Give us the camps as fast as you can." (Courtesy of CCC Legacy.)

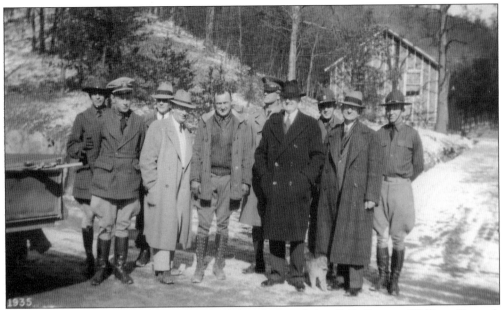

While most of these men are unidentified, fourth from left is R.E. Burson, William Carson's assistant. The other men are CCC supervisors and community leaders. Burson was recruited by Carson in 1926 to visit other states to see how they organized their park systems and make recommendations on how Virginia should organize its. (Courtesy of Smyth County Historical & Museum Society Inc.)

This picture was taken in 1933 at Hungry Mother State Park and was provided by Jimmy Elliott and the Holston Motor Company. From left to right are unidentified, Robert O'dell (assistant to R.E. Burson), C.E. Ward, and G.W. Kearsley. Nattily attired, the men appear to be in good humor and are pleased with their work. (Courtesy of Smyth County Historical & Museum Society Inc.)

This letter from William Carson to President Roosevelt dated May 20, 1933, suggests that Carson had been cultivating Roosevelt since the inception of the CCC. Following a visit to Camp Roosevelt, Carson writes, "If you could have been with me yesterday afternoon it would have done you a lot of good . . . the marvelous change that has taken place in the young men . . . when they first went to the camp they were more or less a slovenly bunch of the 'boxcar riders' type. Today they are a fine, healthy looking lot. The work of reclaiming our forest is a fine one, but what is happening to these young men far outstrips the forestry work. I congratulate you Mr. President on the great work that is being done not only in our forests but with our young men." (Both, courtesy of National Park Service History Collection.)

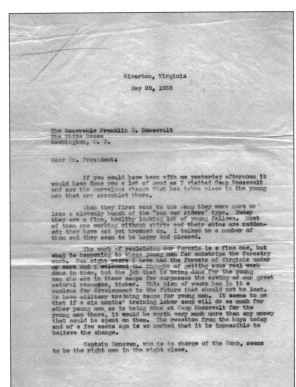

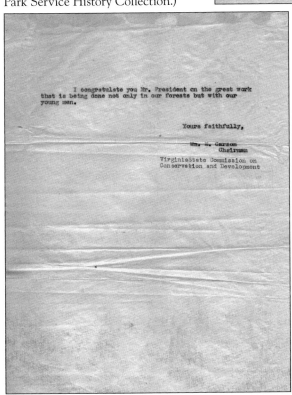

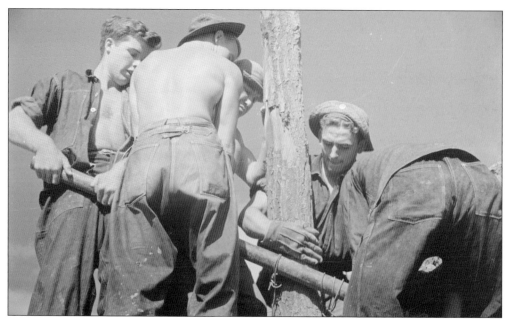

In a short time, malnourished, uneducated, and poverty-stricken young men were transformed into strong-bodied, well-nourished teams. They found their confidence and a place that not only accepted and fed them, but also provided training and education that would lead to a brighter future. These were the results that Roosevelt believed were possible, and it is reported he was quite pleased that he was accomplishing his goals. (Courtesy of CCC Legacy.)

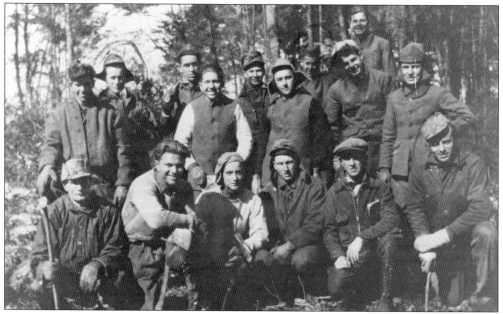

A month to the day after Camp Stratford opened, this photograph of "the gang" was taken on November 16, 1933. Pictured are, from left to right, (first row) Chow Hound Jones, Denny Rankin, Jimmy Reily, Ike Keen, and Mr. B.W. South (foreman); (second row) Owen Parker, Mike Anton, Gus Arm, Tom Salenger, and Ray Gilbert; (third row) Bill Schnelly, Bill Williams, Pete Vodzin, Jack Speight, and Doc Davidson. (Courtesy of Westmoreland State Park Archives.)

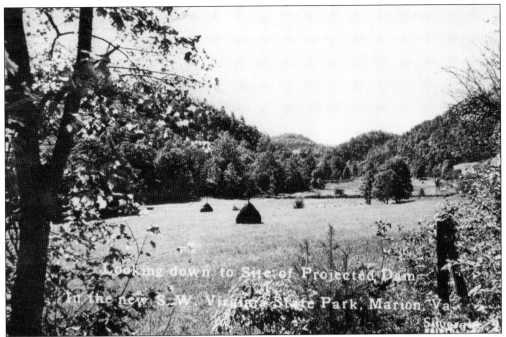

Looking down to Site of Projected Dam In the new S-W Virginia State Park, Marion, Va.

Roosevelt inspired everyone to dream big. These before and after images show the transformation from farm field to Hungry Mother Lake as viewed from the beach area. The engineers, surveyors, and park planners scouted the best location for a lake and where the dam should be installed to hold back the water. These photographs capture the results of their vision. In about two and a half years' time, the work on Hungry Mother Lake was done, and the park was open for business. Today, the project would likely still be in the planning stage. (Both, courtesy of Smyth County Historical & Museum Society Inc.)

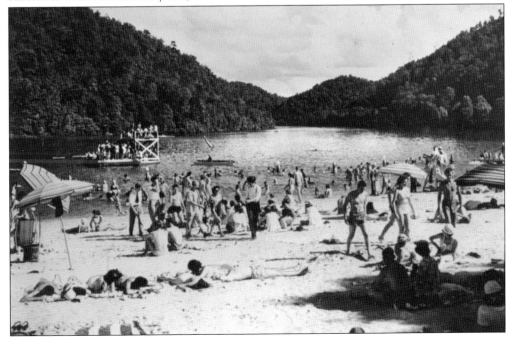

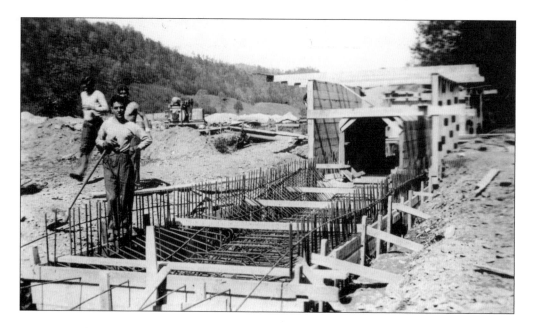

Hungry Mother Lake would be the centerpiece of this new mountain park, and it would require a substantial dam to hold back the water that would make the lake one of southwest Virginia's great scenic and recreational attractions. It would require expert engineering and quality construction if it were to serve generations of users as was hoped. The work on the dam was one of the best chronicled of the construction projects, and its development is featured on several more pages. In these photographs, the manpower and the engineering are on display. (Both, courtesy of Smyth County Historical & Museum Society Inc.)

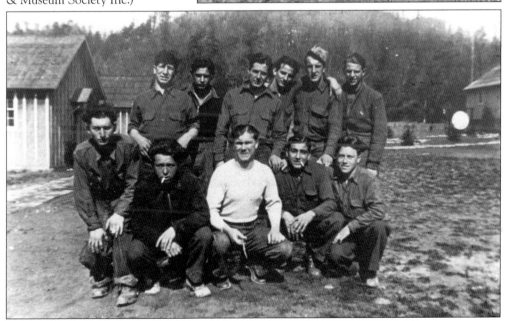

Both of these photographs show the large saw blade that was converted to be a gong, probably used to call the men to assembly. Many camps had standard issue bells, but at Hungry Mother, they appear to have improvised. They had a bell as well to call men to action if a forest fire was sighted. Either ringing the gong or showing off the diameter of the large saw blade was something the men enjoyed doing, or the young man at right would not be posing in front of it. (Both, courtesy of Smyth County Historical & Museum Society Inc.)

Harvesting and moving construction supplies were made easier by laying rails. The CCC practiced sustainable building practices by acquiring its building materials locally and on site if at all possible. These practices saved time, money, and the fuel that would have otherwise been used to ship it. (Courtesy of Smyth County Historical & Museum Society Inc.)

A bridge across the headwaters of Hungry Mother Lake was required to get men and supplies to the cabin area. Today, the bridge is a signal to cabin guests and those who will be staying in the Hungry Mother Lodge that they are close to their destination. (Courtesy of Smyth County Historical & Museum Society Inc.)

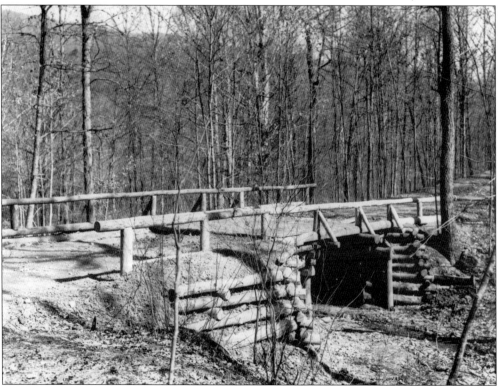

Pictured on October 15, 1933, is the new camp at Hungry Mother State Park. Similar camps arrived at Douthat, Fairy Stone, Staunton River, Westmoreland, and Seashore that same week. With winter approaching, there would have been pressure to get the camps up and running quickly and to build as many wood-frame buildings as possible. (Courtesy of Smyth County Historical & Museum Society Inc.)

Construction of this camp at Hungry Mother was delayed, and the men were required to spend much of an unusually cold fall in their tents. Local experienced men (LEMs) were hired to assist with the building of the permanent barracks. They moved into the barracks before spring 1934. (Courtesy of Smyth County Historical & Museum Society Inc.)

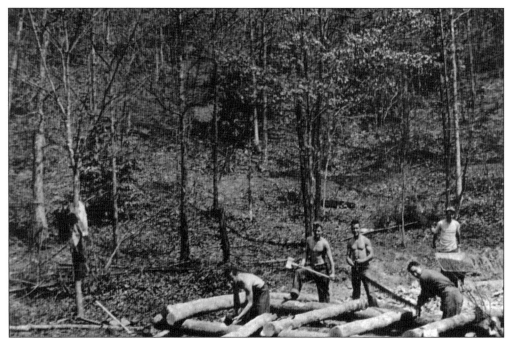

The boys of the CCC became proficient at choosing the right trees and preparing them to make log structures. In this case they are harvesting chestnut trees that had not yet been destroyed by the blight that has persistently killed American chestnut trees since it arrived from the Far East in the early 20th century. They were looking for the best logs to be used in a lodge that would be a showplace for the future park. Both Hungry Mother and Douthat State Park built lodges high above their lakes that functioned like a bed and breakfast. These lodges have undergone several renovations and remain in service. They sleep 16 and are among the most popular of the state park facilities. (Both, courtesy of Smyth County Historical & Museum Society Inc.)

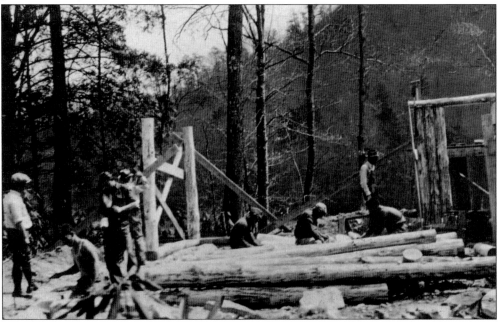

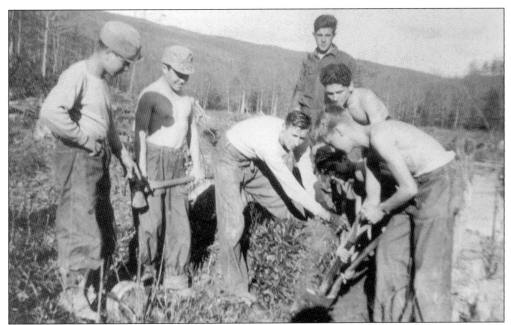

These six men, from left to right, F. Baressel, H. Dugan, assistant leader J. Timko, ? Buntz, ? Cohen, and A. Williams, were proud to demonstrate their expertise as nurserymen for the camera. They began by digging around the entire plant and then getting deep enough to remove it without damaging the roots. Next they would load it onto a wooden structure to be transplanted. (Courtesy of Smyth County Historical & Museum Society Inc.)

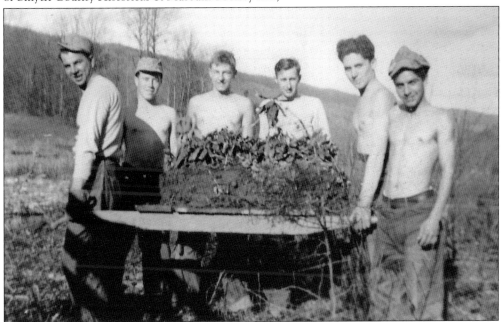

Some of the most spectacular scenery in Virginia's CCC-era parks is a result of the young men moving rhododendron and mountain laurel to select locations within the new park. Their attention to detail of landscape design may be most appreciated at Hungry Mother and Douthat State Parks. (Courtesy of Smyth County Historical & Museum Society Inc.)

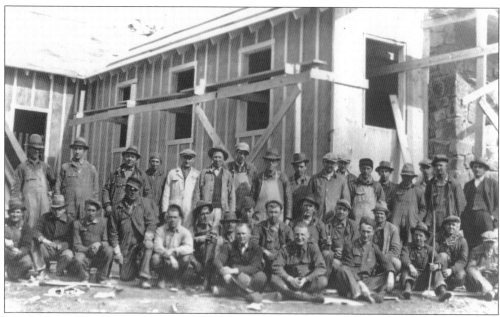

Local carpenters who helped build barracks and other permanent structures are pictured here. Pride in the work they were doing is obvious and their knowledge and trades skills were being passed on to the young men. A testament to their skill is the fact that many facilities they built are still standing. (Courtesy of Smyth County Historical & Museum Society Inc.)

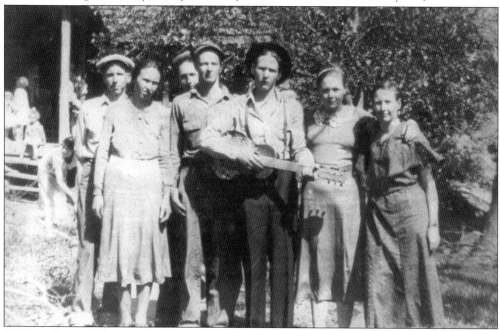

In Scott County, Virginia, lived a young man named Thadys Emory Short. He enlisted in the CCC and worked at Hungry Mother State Park. As his son tells the story, they could not drive past the park in later years without his dad saying, "I built that park. That's my park." There is no question in Ron Short's mind that his dad's experience in the CCC was a highlight of his life. (Courtesy of Ron Short.)

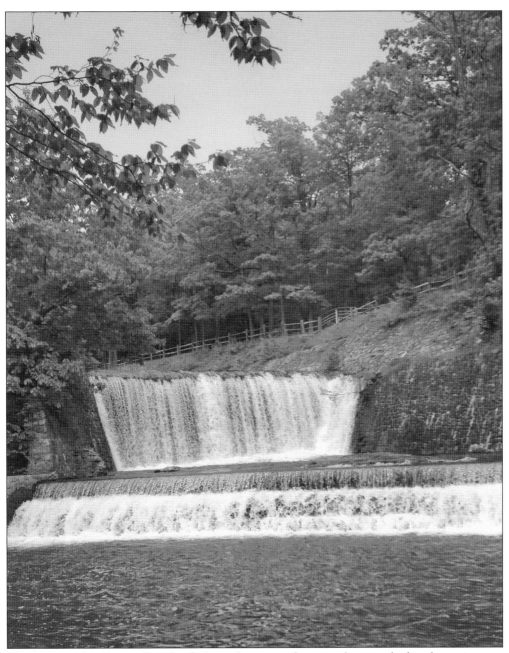

The four-tiered spillway at Douthat Lake ranks among the most photographed in the entire state park system. It is an easy hike from the park's restaurant and picnic areas. The picnic area adjacent to the spillway is the site of Camp Carson, named for William E. Carson. The following three companies were established in 1933 at Douthat State Park: Company No. 1378, SP-2; Company No. 1373, SP-3; and Company No. 1374, SP-4. The boys arrived by rail at the depot in Clifton Forge. The lake is stocked in season with rainbow trout by the Virginia Department of Game and Inland Fisheries. Trout are also in the stream below the dam and spillway. Part of the area is designated as a 12-years-and-younger-only fishing area. Trout and typical warm-water fish species can be caught in the lake and streams. (Authors' collection.)

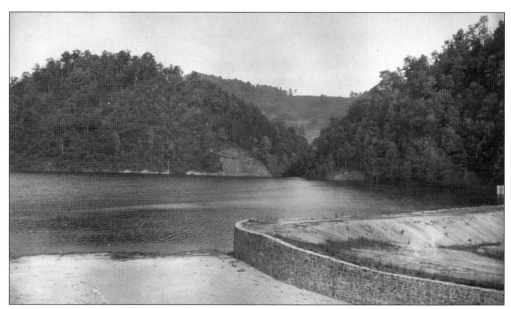

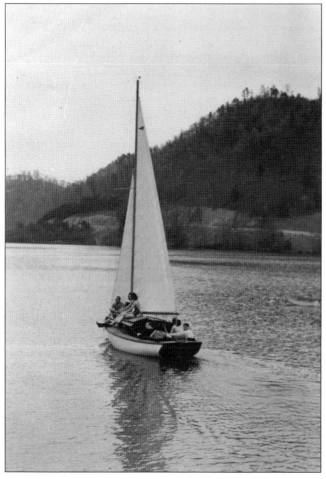

The spillway at Hungry Mother is not nearly as scenic as the one at Douthat, but both lakes are beautiful and offer outstanding recreation. The people on the sailboat at left are enjoying a nice day at Hungry Mother Lake. This boat's owner was John D. Lincoln, one of the local philanthropists who had gifted land to the commonwealth for the state park at Will Carson's urging. Property records indicate the land Lincoln donated was once owned by Benjamin Franklin Buchanan, Virginia's lieutenant governor from 1918 to 1922. Lincoln was at the grand-opening ceremony at Hungry Mother when Gov. George C. Peery gave the keynote address. (Both, courtesy of Smyth County Historical & Museum Society Inc.)

Working as a lifeguard at a state park beach has been many a teenager's idea of the perfect summer job. The first lifeguards hired are pictured above with Commodore W.E. Longfellow, director of Water Life Saving for the American Red Cross as well as director of the Neptune Festival and Bathing Beauty Pageant. The white-sand beach was made possible by John D. Lincoln of nearby Marion. He sent a rail car to Virginia Beach and had it filled up with sand from the oceanfront. It was so popular with park visitors that state parks made white sand beaches the norm. The Bathing Beauty Pageant was a popular event at the parks for a number of years. It was quite the honor for a girl to be selected as Miss Hungry Mother. (Both, courtesy of Smyth County Historical & Museum Society Inc.)

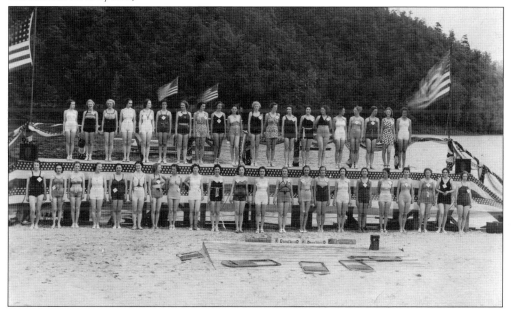

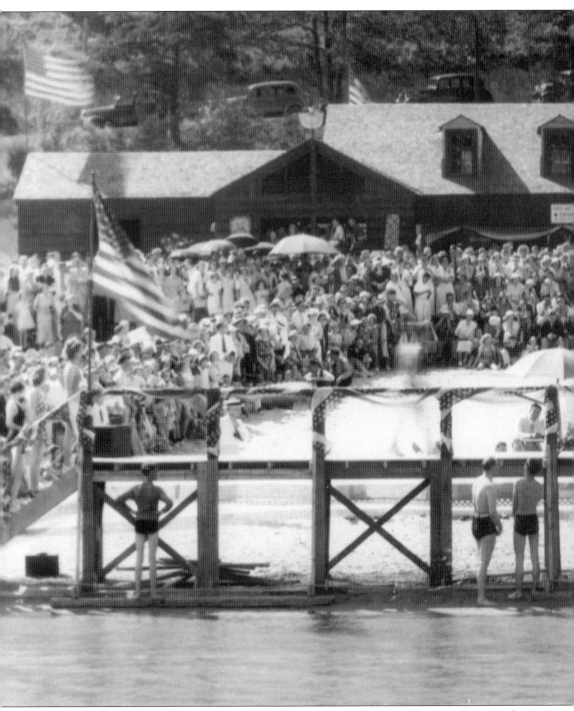

The grand opening of the Virginia State Parks System was a big deal. Hungry Mother was chosen for the event because its development was further along. Officials from the federal and state government had to be impressed with the throng of citizens, estimated to be more than 5,000, who made the trip from all across the state for the momentous occasion. In addition to the opening ceremony, the day included a Neptune Festival and Bathing Beauty Pageant. Governor Peery said

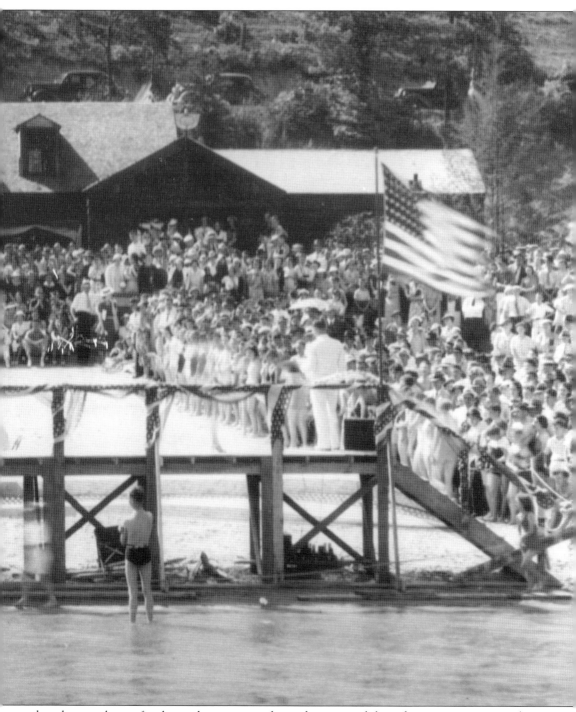

that these parks are for the working man, and it is the responsibility of government to provide him with some of the pleasures life has to offer. He also remarked that if places such as this are built for the citizens, there will be no place in the United States for Fascism, Communism, and Nazism. (Courtesy of Smyth County Historical & Museum Society Inc.)

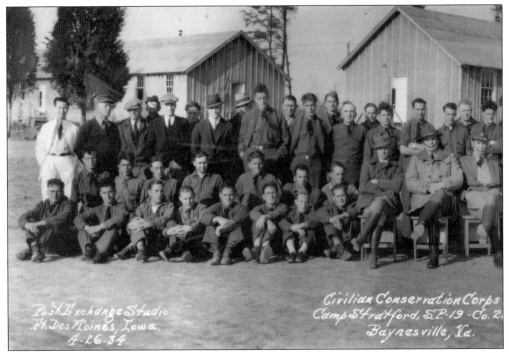

Post Exchange Studio
Ft. Des Moines, Iowa.
4-26-34

Civilian Conservation Corps
Camp Stratford, SP-19 - Co. 2.
Baynesville, Va.

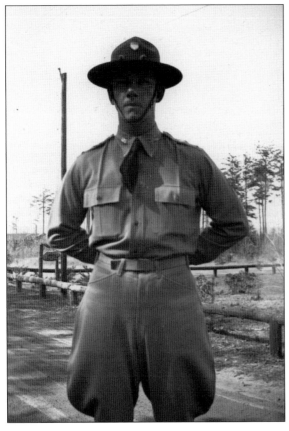

On Virginia's historic Northern Neck along the Potomac River, Camp Stratford, Company NO. 287, SP-19, was established to build a state park in Westmoreland County between George Washington's birthplace and Stratford Hall, the ancestral home and birthplace of Robert E. Lee. Its company commander was Capt. T.W. Poindexter, who was assisted by 2nd Lt. H.H. Phelps and project superintendent J.E. Bishop. (Courtesy of Westmoreland State Park Archives.)

The company officers were responsible for running a complex operation with enormous logistical and human resource challenges. Here, 2nd Lt. William E. Wilhelm cuts an imposing image of respect in 1935. Wilhelm was at Camp Stratford and with Company No. 287; the company worked on building Westmoreland State Park, projects at George Washington's birthplace, and other locations in the area. (Courtesy of Westmoreland State Park Archives.)

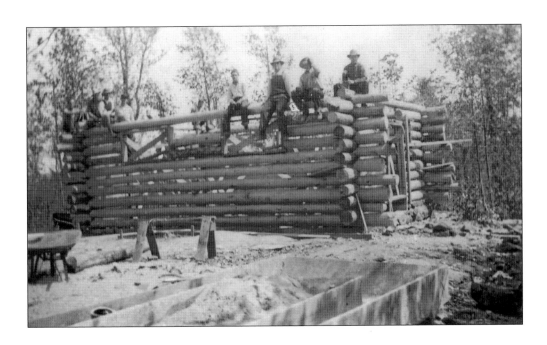

Locally harvested logs were used in the construction of Westmoreland's cabins and facilities. This building was designed initially as a restroom for guests. Later, the restroom was remodeled into an efficiency overnight cabin, and today, it is cabin No. 32. Virginia's six original CCC state parks, opened on June 15, 1936, were all designed as destination parks that offered both rustic cabins and campgrounds. One tip-off that this log structure was a restroom is that the windows were higher up from the ground than in the regular cabins. This was done to provide more privacy. (Both, courtesy of Westmoreland State Park Archives.)

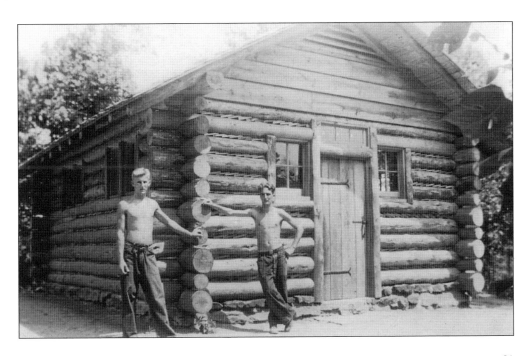

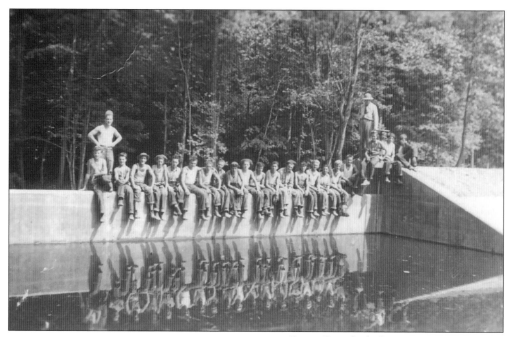

Camp Stratford, Company No. 287 required fresh water for drinking, cooking, and bathing. Getting the water system up and running would have been a high-priority project for every camp. In this case, a concrete reservoir was built to catch water from a small tributary of the Potomac River. Over time, drilled wells or public water systems were developed and used by the parks to provide an even better and more efficient source of water. Water and waste water facilities, like Rock Creek pond at Westmoreland State Park, often became wildlife habitats and the focus of environmental education programming. Some water towers, like the one at left at Company No. 287's camp, with its proud builders and users posing in front of it, are still visible throughout the system, but most are out of use and serve as reminders of the bygone days. Larger, ground-level submarine-shaped tanks replaced many of these as electric motors made gravity less important for water circulation. Projects like the reservoir and camp water tower would have been natural photograph opportunities for the camp's enrollees. (Both, courtesy of Westmoreland State Park Archives.)

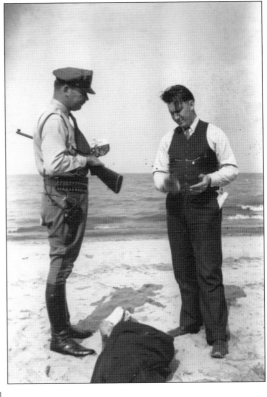

At first blush, it looks as though a state policeman has asked a man on the beach to produce some identification, or perhaps his state fishing license. In reality, the caption reads, "Virginia State Policeman with Educational Advisor," and is dated 1935. That suggests that the educational advisor was someone working with the enrollees on getting their high school diplomas and other certifications provided through programming at the camp. The enrollees below are enjoying time at the beach along the Potomac River. They appear to be posing in front of a bulletin board that may have provided information to visitors about boating, fishing, swimming, and sunbathing along the riverfront. (Both, courtesy of Westmoreland State Park Archives.)

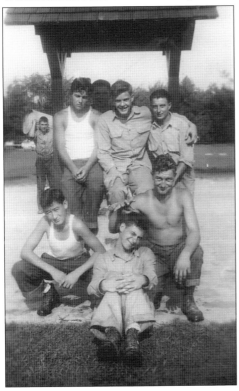

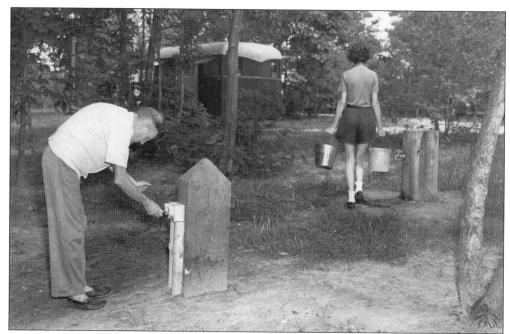

Arthur Sherman started manufacturing travel trailers in the 1930s. The trailer was an alternative to traditional travel, which normally included train fares and hotel bills. Many travel trailers were homemade, and a manufactured one cost approximately $300. The Westmoreland campground offered both electricity and water. Decades later, park rangers still marvel at the water coming out of a spigot in a cedar stump (at right) from buried water lines. (Courtesy of Westmoreland State Park Archives.)

These campers were among the earliest at Westmoreland State Park. Their car bears a 1937 license plate. Water and electricity were available on the campground, as well as a bathhouse. From their opening in 1936 until the 1990s, campgrounds were only open from Memorial Day through Labor Day. Now, they open in March and close the first week of December. (Courtesy of Westmoreland State Park Archives.)

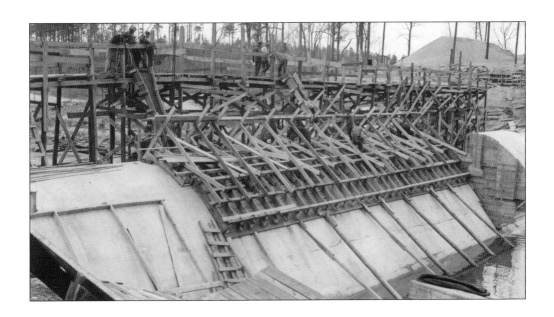

The dam pictured above is on Swift Creek in Pocahontas State Park in central Virginia. All the dams built in this era were feats of engineering. Each was built by the local camps established to build the park. In most cases, it was the only dam project the CCC boys would ever work on. The engineering and design of dams were something the National Park Service was getting a good bit of experience with, and in Virginia State Parks alone, they designed dams at Douthat, Hungry Mother, Fairy Stone, Pocahontas, and Prince William Forest. (Both, courtesy of National Park Service History Collection.)

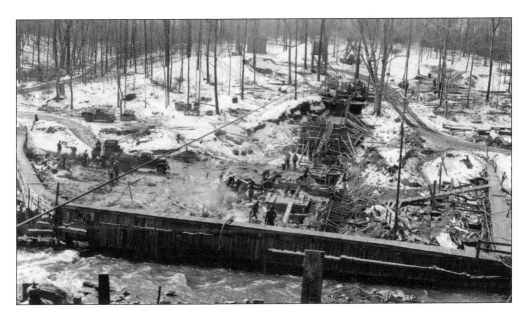

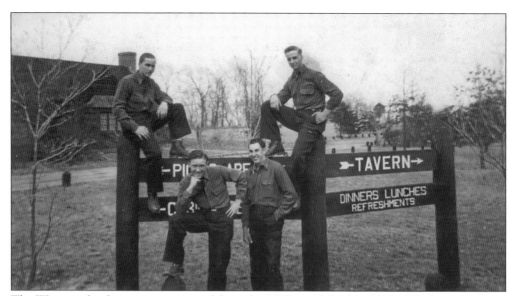

The Westmoreland restaurant operated from the 1930s until the late 1990s. The boys above are posing with the sign for the Tavern, which was later renamed the Restaurant. Restaurants in nearby Montross made it difficult for Westmoreland's restaurant to be profitable in an era when parks were being pushed to be more self-sufficient. It was converted into a multipurpose meeting hall and renamed the Helen and Tayloe Murphy Hall after W. Tayloe Murphy, who had served for many years in the Virginia House of Delegates and as secretary of natural resources under Gov. Mark Warner. His wife, Helen, had been appointed to the Caledon Natural Area Advisory Committee in the 1980s and reappointed in the 1990s by state parks director Joe Elton. Restaurants remain successful at Hungry Mother and Douthat State Parks. (Above, courtesy of Westmoreland State Park Archives; below, authors' collection.)

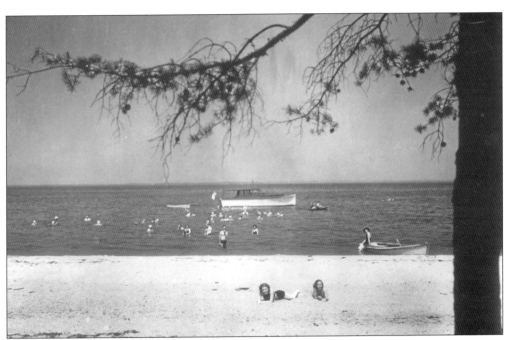

At Hungry Mother, Douthat, Fairy Stone, and Pocahontas, dams were built on small streams to create recreational lakes. At Staunton River, Westmoreland, and Seashore State Parks, natural water features were the focus. Staunton River State Park was built at the confluence of the Dan and Staunton Rivers, which provided good fishing and boating venues. Silt in the rivers made them unpleasant for swimming, so a beautiful swimming pool was built with funds provided by Halifax and Mecklenburg Counties and the Town of South Boston. Westmoreland's beach is on the Potomac River and Seashore is on the Chesapeake Bay. (Both, courtesy of Westmoreland State Park Archives.)

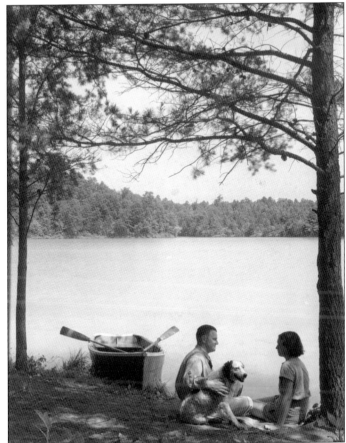

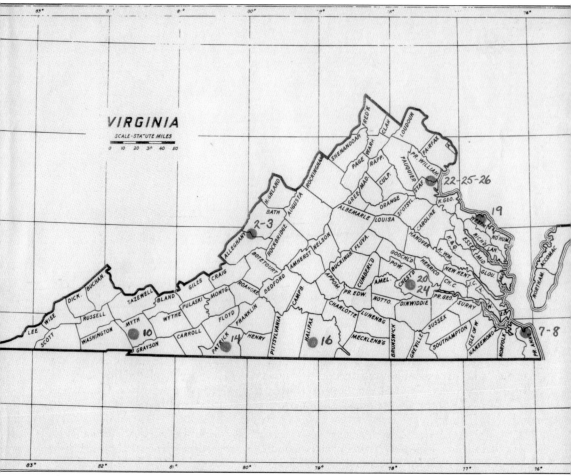

This map shows the locations of the camps William Carson was able to get from his discussion with Roosevelt. Those camps began operating on October 15, 1933, just 60 days after their discussion. In order to make the camps possible, Carson arranged for donations of land for four of them, Douthat, Hungry Mother, Fairy Stone, and Seashore, and convinced the state legislature to provide funds to acquire additional land for Seashore, Staunton River, and Westmoreland. Carson and Roosevelt knew how to make things happen. They built the first seven Virginia state parks, six of which opened on June 15, 1936. Carson felt that the first six state parks, along with Shenandoah National Park, would place outdoor recreation facilities within an hour's drive of every Virginian. Today, those parks are among the most popular in Virginia's nationally acclaimed, award-winning park system. (Courtesy National Park Service History Collection.)

Five

CAMP LIFE

The Army was tasked with managing the CCC camps. Army discipline was a first for the majority of recruits, who arrived hungry and uneducated but with a spirit of hope and ready for work. Few enlistees dropped out. The first enrollees came from families receiving assistance. Criteria was firm: male, between the age of 18 and 25, unmarried, unemployed, willing to work for $30 per month with $25 going back home, and willing to work for six months.

The majority of the camps were the same. Most averaged 200 young men, a company commander, junior officer, camp doctor, educational advisor, and assistant leaders. The typical camp had 24 buildings, which included officer and enlisted personnel quarters, barracks, kitchen and mess hall, school and recreation buildings, and bathhouse facilities.

Men were expected to get along with others, from bunkmates to commanding officers. They were to maintain personal hygiene and were rewarded with warm clothing, three square meals a day, and a few shekels in their pocket.

Many arrived with little or no education. Many lacked the opportunity or encouragement to further their education. The War Department changed that. With assistance from the Bureau of Education, programs were devised to offer the greatest opportunity to the broadest spectrum of men. Their goal was to return these men to their homes better qualified. Rudimentary subjects were taught including reading, writing, and arithmetic. Men with an aptitude and desire to learn more were offered vocational instruction in mechanics, truck driving, road building, surveying, and more. Others sharpened their writing, typing, and bookkeeping skills. And yet others learned timbering, radio communication, carpentry, and other trades.

The day's regime began at 0600 and ended at 2300 with bed check. To paraphrase Will Carson's letter to FDR, "a slovenly bunch of boxcar riders went back home stronger, tanned, disciplined, and equipped with skills and an appreciation for our nation's natural resources."

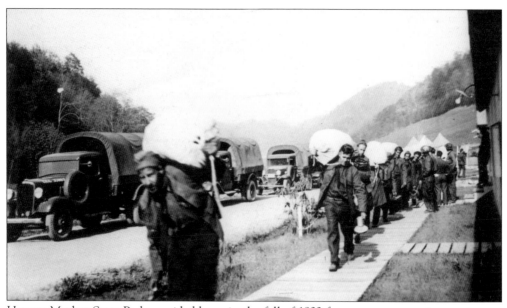

Hungry Mother State Park provided hope in the fall of 1933 for a young generation anxious to work and suffering from no fault of their own. Eligibility criteria was as follows: citizen of United States, male, physically fit, between 18 and 25 years old, unmarried, unemployed, acceptance of a $30 wage per month with $25 going home to family, and a willingness to volunteer for a minimum of six months. (Courtesy of Smyth County Historical & Museum Society Inc.)

The President's Greetings

I welcome the opportunity to extend a greeting to the men who constitute the Civilian Conservation Corps. It is my belief that what is being accomplished will conserve our national resources, create future national wealth and prove of moral and spiritual value, not only to those of you who are taking part, but to the rest of the country as well.

You young men who are enrolled in this work are to be congratulated. It is my honest conviction that what you are doing in the way of constructive service will bring you, personally and individually, returns the value of which it is difficult to estimate.

Physically fit, as demonstrated by the examinations you took before entering the camps, the clean life and hard work in which you are engaged cannot fail to help your physical condition and you should emerge from this experience, strong and rugged and ready for re-entrance into the ranks of industry, better equipped than before.

I want to congratulate you on the opportunity you have, and to extend to you my appreciation for the hearty cooperation which you have given this movement, so vital a step in the nation's fight for progress, and to wish you a pleasant, wholesome and constructive stay in the CCC.

Franklin D. Roosevelt

What The CCC Is

THE Civilian Conservation Corps is part of the U. S. Government. It provides jobs and training for energetic young men. It conserves and replenishes the public lands of the country. Hundreds of camps have been set up in forests and parks and on soil-eroded farmlands. There are camps in every state, in Alaska and in U. S. island possessions. More than two and a half million boys have lived and worked in these camps since 1933, making $30 a month and sending part of it home.

Life in a CCC camp is a different kind of life than most boys have known. An enrollee, as a CCC man is called, does not have his own private room. There is no one to pamper him with tempting dishes when his appetite is off. He lives with 200 other men of his own age, in barracks. They work, play and eat together. Learning to get along with 199 other men without hurt feelings or broken noses is one thing every enrollee must learn while in camp. CCC camp life is a healthful one. It offers many opportunities for self improvement, physically, mentally and vocationally. Boys who "can take it" will get much out of the CCC. They well may be proud of belonging to such an organization.

The purpose of this handbook is to tell what the CCC is, how it operates and how all enrollees

5

Organization was the key for FDR's New Deal. He saw to the grandeur as well as the details. CCC boys were handed an entry book upon their acceptance into the program. From the start, Roosevelt made sure the boys knew what was and was not expected from each and how their personal success would benefit them, their family, and the nation as a whole. (Courtesy of Virginia State Parks.)

The operation of the CCC was in the hands of the Department of War. Each enrollee was given the following supplies: three underwear, six pairs of stockings, two pairs of shoes (work and dress), two pairs of denim trousers and jumpers, one pair of woolen trousers, two flannel shirts, one tie, one belt, one hat, one raincoat, one overcoat, one pair of gloves, a barrack bag, two blankets, and where necessary—a toilet set. A pine footlocker with metal latches, similar to what military personnel would have been assigned, was provided to each CCC boy. They came to be known as footlockers because they were located at the foot of enrollees' beds. Several alumni have said little effort was made to give the boys the right size clothes and shoes. A lot of horse-trading took place. (Both, courtesy of National Park Service History Collection.)

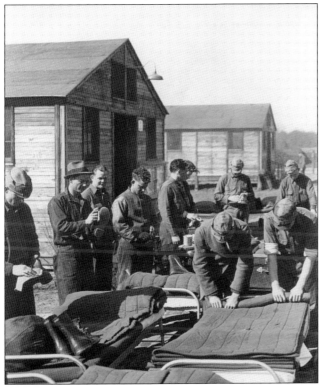

The first camp of Roosevelt's Tree Army was established within a week. Across the nation, an average month enrolled 3,000 boys each day, and by July 1933, over a quarter million enrollees worked at 1,300 camps throughout America. Immunizations and haircuts were given within hours of the boys reaching their training camp. The boys' hairstyles became a laughing matter. Above is a line-up of enrollees waiting their turn at the clippers. "Wally" was one of several CCC cartoonists who chronicled CCC life. In the image below, he captures the comical haircuts that would have been popular among enrollees. The cartoons would have been viewed in camp newsletters with the more popular cartoons published in *Happy Days*, a weekly nationwide newspaper. (Above, courtesy of Smyth County Historical & Museum Society Inc.; below, courtesy of CCC Legacy.)

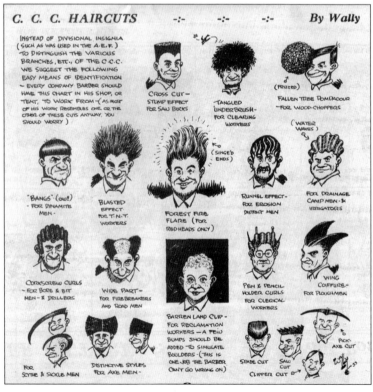

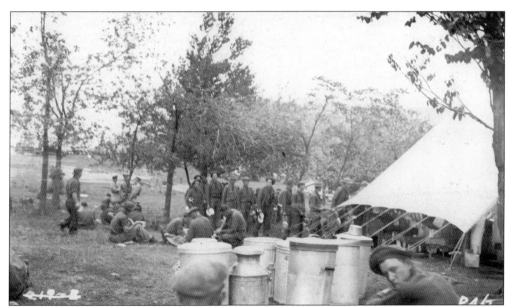

To remain in the CCC, much was expected, but much was given. Within several months, men were healthier and gained new muscle strength, a tan, and disciplined attitudes. They rose early and worked late. In between came education, recreation, and three square meals a day—a first for many enrollees. Pictured is a Virginia camp prior to its permanent kitchen and mess hall being constructed. (Courtesy of National Park Service History Collection.)

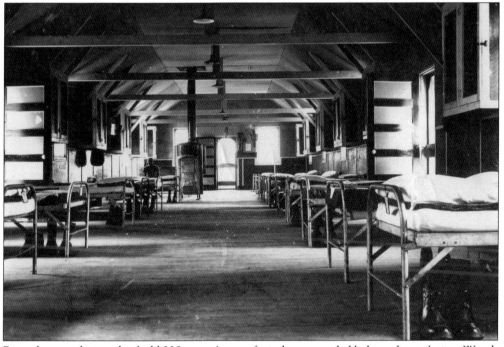

Barracks were designed to hold 200 men. A row of windows provided light and ventilation. Wood-burning stoves provided warmth in the winter. Squeaky metal cots lined the exterior walls. A pathway led straight down the middle. A trunk with the enrollee's allotment was kept at the end of each cot, doubling as a seat. (Courtesy of US Forest Service, Lee Ranger District.)

Mealtime on the ground would soon end for the CCC boys as they anxiously waited for the permanent kitchen and mess hall building at the nation's first CCC camp, Camp Roosevelt, located in George Washington National Forest. Morale was high among the corps who received three square meals a day and $30 per month with $25 going back home to assist family members. (Courtesy of US Forest Service, Lee Ranger District.)

Building designs were kept simple, making duplication of projects expedient. Camp Roosevelt's kitchen and mess hall was duplicated throughout America. Many buildings remain functional to this day due to the craftsmanship of LEMs (local experienced men), who had trade skills and lived in close proximity to a camp and supervised the boys. (Courtesy of US Forest Service, Lee Ranger District.)

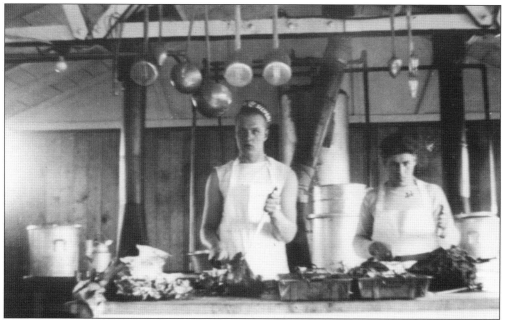

Food served at the camps was fit for all, from royalty to worker. Pictured above, boys at Prince William Forest Camp No. 2349 take pride in their culinary skill. Below, boys at Hungry Mother seem delighted with the menu, which often consisted of fried breast of chicken, new potatoes, garden peas, brandied peach, chiffonade salad, dinner rolls, Neapolitan brick ice cream, and homemade layer cake. And of course, coffee. Franklin Delano Roosevelt commented that in a few short months, even with all the hard work, the boys had gained 12 pounds on average. (Above, courtesy of National Park Service Archives, Prince William Forest; below, courtesy of Virginia State Parks.)

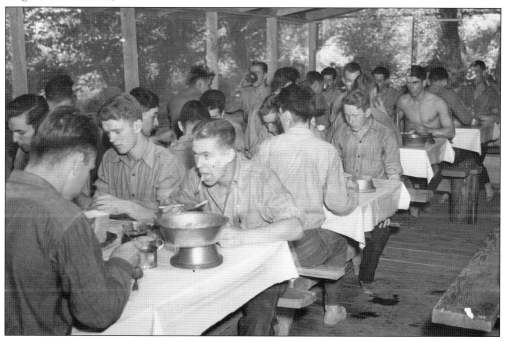

Schooling was optional for the enrollees. Most arrived with less than a ninth-grade education, some had high school diplomas, and even a few college grads were among the ranks. There was no set curriculum and no criteria for enrollment. Run by the War Department, Robert Fechner enlisted the counsel of the Department of Education with the goal of returning men home ready to compete in the workforce with a better understanding of their country and themselves. Instruction had to be adapted to the boys and relate to their strengths, be it mechanics, carpentry, writing, electronics, or radio communication. All were important skills for the impending World War II. (Above, courtesy of National Park Service Archives, Prince William Forest; below, courtesy of Virginia State Parks.)

Books often arrived through donations from local families and churches. Instructional texts were purchased, making the library an essential element for a mind-enriching experience. In addition to the boys gathering to study, they were offered local newspapers and novels for enjoyment. Many took advantage of the quiet time writing correspondence to their loved ones back home. It was also a location where many learned to read. Pictured at right are four 1939 enrollees from CCC Company No. 1387, stationed at NP-3, Skyline Drive in Elkton, Virginia, on the library steps. Below, a potbelly stove adds to the comfort of the building. (Both, courtesy of US Forest Service, Lee Ranger District.)

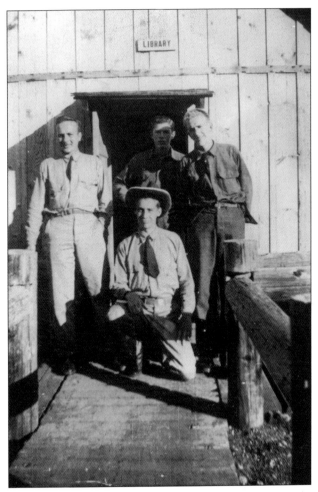

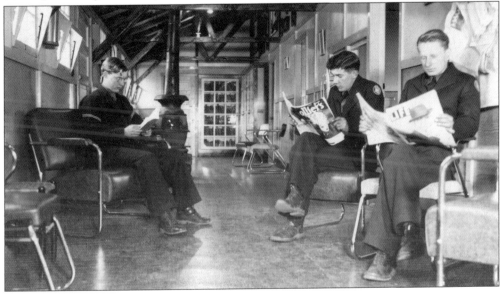

"SPUDS" 50 "DEAR MOM"

Homesickness hit many of the recruits who were experiencing separation from loved ones for the first time in their young lives. Close living quarters with other recruits, demanding officers, and long days filled with hard work played havoc with many of the enrollees. But good hearty meals, a paycheck, and new friends cured homesickness for most. However, for whatever reason, some young men could not cope and either deserted or were dishonorably discharged. CCC artist Marshall Davis captured with pencil and paper the feelings many young boys experienced in their early days of camp life. Davis was particularly adept at capturing the mood of the boys since he was a struggling artist who joined the corps as a laborer. Carrying along his sketch pad and pencils, he embarked on a pictorial history unrealized at the time but greatly valued today. (Courtesy of CCC Legacy.)

Free time was also an opportunity to browse the CCC's product catalog of personal effects that the enrollee might desire for oneself or an array of gifts specifically designed for loved ones back home. Most gifts were emblazoned with the CCC logo, the American flag, or other patriotic symbols. Catalogs featured jewelry for both men and women, wall pennants, and scarves. One of the most popular items were embroidered pillow covers, as pictured here. One is addressed to "Mother," while the other reads, "Sweetheart." Still more were available, such as one to "Mother and Father," all with heartfelt expressions. (Both, authors' collection.)

FIGHT NIGHT 100 "COMIN' HOME"

Nearly all enrollees arrived at camp as undernourished, slovenly, and destitute boys. Camp life changed that for those who endured. They became well-nourished, trained, and disciplined, and learned important matters pertaining to everyday life. The life-lessons gained pertained to money, people, time management, and much more. Free time was enthusiastically embraced. In addition to educational training, many of the new friendships evolved into competitive sports, such as boxing tournaments and baseball games. At left, Marshall Davis illustrated both. Below, unidentified men can be seen enjoying a swim. (Left, courtesy of CCC Legacy; below, courtesy of National Park Service History Collection.)

Six

ACCOMPLISHMENTS
OF THE CCC

Roosevelt's CCC was a recovery program that he personally envisioned and promoted. It was central to launching the presidency of a man who had promised much and who was driven to deliver. He approached governing with a zeal that surprised some and overwhelmed many. He led by example and inspired many to do the same. He saw the big picture and knew that failure was not an option. His personality was infectious, and his can-do spirit inspired many. He truly enjoyed people from all walks of life, and it showed. His 100 Days recovery campaign put America on course to a brighter future and established him as a leader of unparalleled ability, energy, and vision. It set the stage for him to be the only president elected to four terms. Secretary of Labor Frances Perkins called him the most complicated person she had ever met.

Over $190 million was spent over the nine-year period in Virginia, the fifth-largest statewide expenditure in the country. Virginia ranked fourth in the number of camps with 75,000 men, 10,000 of whom held the rank of officer or supervisor. Despite segregation, which was especially strong in Virginia, about 250,000 of the three million young men who served in the CCC were black.

The CCC not only built the character of the young men, their LEMs, and the military personnel who helped run the program, but it also built the character and confidence of a nation that had been dragged down by the Great Depression.

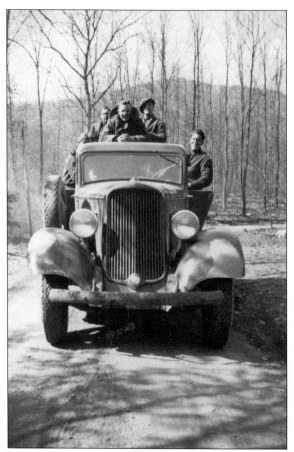

Virginia was uplifted sociologically and economically by the materials, supplies, and equipment required by the CCC. It was not long until their accomplishments lifted the country as a whole. It advanced America's standard of living and improved the citizens' outlook. Over a nine-year history, more than 75,000 Virginians served in the commonwealth's camps. 34,000 from other states served in Virginia. Pictured at left, Camp Roosevelt boys make their way to the job site, smiling and thankful for a day's hard work. One of the major, enduring accomplishments were the miles of road built and the 986 bridges constructed, allowing better access to rural communities and their surrounding forestland. The CCC spurred jobs in the private sector, where the heavy equipment was produced in factories that needed work after the stagnation caused by the Great Depression. (Both, courtesy of US Forest Service, Lee Ranger District.)

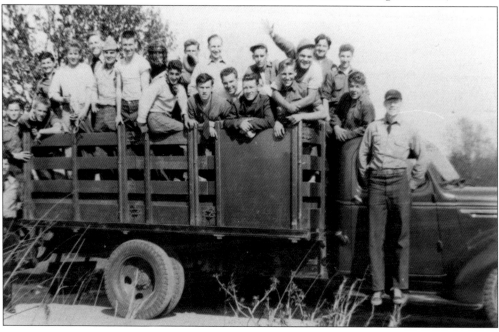

The CCC boys built 3,470 lookout towers in America. They manned the steel towers while others dug miles of fire break line. At the first sight of smoke, a warning call traveled through 2,128 miles of newly hung phone lines. In Virginia, 152,000 acres of fire hazards were reduced. Steel and wire arrived via the railroad, creating demand in private industry. (Courtesy of National Park Service History Collection.)

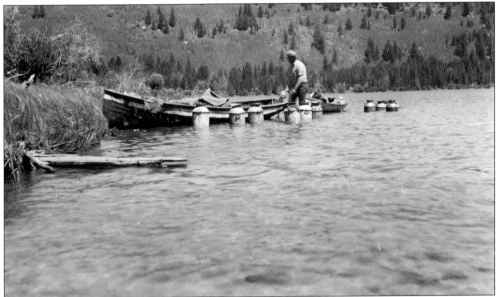

CCC boys helped restore wildlife habitats. In January 1940, Camp Cherokee in Bland County experienced a bitter cold spell. Boys reported finding starved and frozen birds. They carried food to coveys of woodland birds. Pictured is an officer releasing fry into one of the 4,622 fish-rearing ponds created by the CCC. In Virginia, 1.3 million fish were stocked during the nine years. (Courtesy of National Park Service History Collection.)

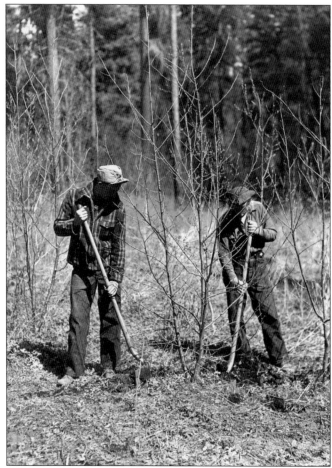

Nothing went unplanned in the CCC, including the planting of over 3 million trees and 15.2 million seedlings in Virginia. A training booklet, titled *Tree Moving*, was distributed by the Army. Instructions read as follows: "Evergreens and deciduous trees in leaf are balled. . . . Balls are wrapped in single thickness burlap. Gunny sacks are ripped open along the sewed seam [and] eight penny box nails are used like pins to secure burlap." Below, the CCC boys stationed at Hungry Mother State Park are cleaning their equipment and vehicles after transplanting shrubbery and performing various other timber projects including building forest roads. Nationwide, 45 million trees and shrubs were moved for landscaping. (Left, courtesy of National Park Service History Collection; below, courtesy of Virginia State Parks.)

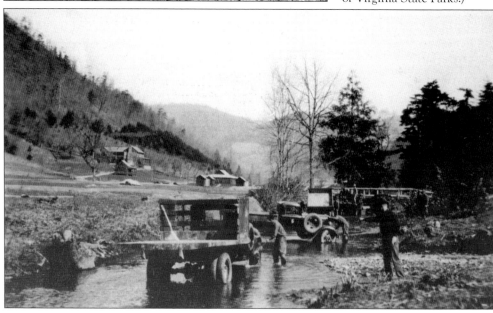

The CCC surveyed and mapped millions of acres and thousands of lakes. Some 1,800 drinking fountains dotted the public lands. Mostly unseen were the 8,065 wells and pump houses. There were more than 5,000 miles of waterline created. Douthat State Park offered new CCC cabins with new conveniences many had not experienced at the time. (Authors' collection.)

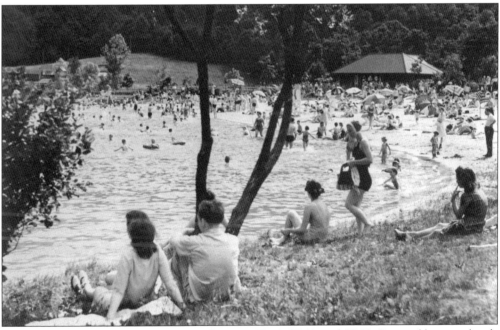

Smyth County was a large beneficiary of Camps SP-10, SP-11, and SP-12. Pictured here are locals enjoying one of the 3,462 beaches improved during the nine-year New Deal experiment, which also resulted in 46,854 bridges built and 27,191 miles of fence. (Courtesy of Smyth County Historical & Museum Society Inc.)

Speed and Driving Rules for Motor Trucks

1. All State, municipal, and local laws and regulations must be obeyed implicitly. (Observe street and highway signs and signals; signal before turning or stopping; give audible horn signal before passing; when stopping, pull to extreme right edge of road.)

2. Except in emergencies involving the protection of life or property, the maximum speed is fixed at miles per hour; within this limitation speed must be so controlled to permit of vehicle being brought to complete stop in half the distance road is clearly visible ahead. (Posted speed limits may be high. Wet, slippery, and icy roads, curves, hills, intersections, fog, bright sun, and glaring lights call for reduced speed. Dim lights for approaching cars. Always drive slow enough to be safe.)

3. Passing is prohibited on hills and curves, at intersections, or railroad crossings. Travel at a safe distance behind when following another car.

4. "Coasting" and "riding the clutch" are prohibited.

5. When driving in cities and towns avoid the congested traffic districts as much as possible.

6. Always travel on right side of the road; always stop before crossing track at grade crossings, and before entering a trunk or arterial highway.

7. Exercise caution when backing—the responsibility is all yours.

8. Always respect the rights of pedestrians.

9. Do not put too much reliance on your brakes, especially during wet weather.

10. Always slow down and when necessary come to complete stop when meeting another vehicle on a narrow road, or when passing cars stopped on roadside.

11. Give animals the right-of-way. They do not obey traffic rules.

12. Treat the other driver as you would have him treat you; remember that he may be inexperienced or may use poor judgment.

13. Drivers must have their permits with them when driving.

14. Not more than one person may ride with the driver in driver's seat. (The Regional Forester or State Forester may authorize two persons to ride with driver in the types of trucks which are manufactured with seats designed to accommodate three persons.)

15. Be especially careful when hauling men. Haul no one not an authorized passenger. Do not allow men to "dangle" their legs over the sides of truck bed or to get on or off while truck is in motion.

16. In case of accident always stop, investigate, and prepare complete report. Render aid in emergency.

17. Trucks may be used only for official business. Switch keys will be turned in to camp superintendent or other designated officer at end of each day's work, or at end of trip if truck is not to be used further.

18. No expense is to be incurred for the repair of a vehicle damaged in an accident until a superior officer has determined the party responsible.

19. Driving while under the influence of intoxicants is prohibited and to do so will be cause for recommendation for dismissal from the Civilian Conservation Corps.

20. Any driver involved in an accident due to his own negligence will be removed from the truck-driving job, and in cases where there is gross or willful negligence, recommendation will be made for dismissal from the Civilian Conservation Corps. Drivers of Government-owned cars are criminally liable to the same extent as drivers of privately-owned cars.

21. ..

22. ..

23. ..

GENERAL.—(a) Trucks will be inspected by competent mechanic at end of each day (motor, brakes, lights, horn, etc.), and when found faulty must not be used until repaired; (b) trucks hauling men will be accompanied by an officer or a responsible man designated to be in charge; (c) if necessary to haul men and tools on the same truck, suitable tool box or container will be provided or adequate care taken to prevent injury to the men; and (d) maximum man-loads will be (1) dump trucks, men in body of truck, (2) stake-side trucks, men in body of truck, (3) pick-up trucks, men in body of truck.

ROPE, KNOTS AND CLIMBING

CIVILIAN CONSERVATION CORPS

UNITED STATES
DEPARTMENT OF THE INTERIOR
NATIONAL PARK SERVICE

CCC accomplishments remain unparalleled into the 21st century; 45,000 boys per year were taught to drive trucks, and over 40,000 young men learned to read and write. Society was prepared for a new era. Forestry departments now had trained arborists, historic grounds had archeologists, and the impending World War II had well-disciplined and physically strong servicemen at hand. Pictured above is the Department of Agriculture rules on speed and driving of motor trucks. One's driving record now was a matter of public record. From the Department of the Interior sprung guidelines essential to personnel in forestry management. Pictured at left is *Tree Preservation Bulletin No. 7*, titled "Rope, Knots and Climbing," which taught skills vital to safely performing arbor work on mature trees. (Above, courtesy of US Forest Service, Lee Ranger District; left, courtesy of National Park Service Archives, Prince William Forest.)

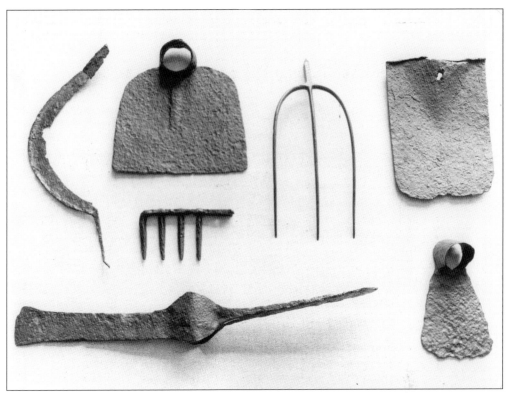

The CCC boys sent to Colonial National Historical Park at Jamestown unearthed, scrubbed, sorted, and cataloged a half million artifacts. Seen in this photograph is a small part of the loan from the Jamestown Museum collection sent for an exhibit at the Jefferson National Expansion Memorial in St. Louis, Missouri, on March 16, 1942. (Courtesy of National Park Service History Collection.)

Newly minted CCC carpenters left their mark on society. Pictured is a fine bookshelf built by the CCC boys for use at Petersburg National Military Park. The battle for Petersburg preceded the fall of Richmond to Union forces on April 3, 1865. This cabinet was made in Company No. 350's woodworking shop at NP-2 near Luray, Virginia; NP-2 was formed on May 15, 1933. (Courtesy of National Park Service History Collection.)

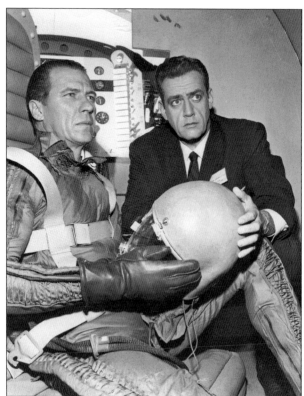

Great men, including a long list who received a Certificate of Valor, emerged from the CCC. Two well-known actors lifted by the CCCs were Robert Bray and Raymond Burr. Bray became a US Marine before starting an acting career portraying a US Forest Service ranger in the *Lassie* series. Raymond Burr is best known for the *Perry Mason* and *Ironsides* series. Another famous CCC enrollee was Walter Matthau. (Courtesy of Edward S. Slagle.)

In this early picture of the Hungry Mother Lake, a car pulls off to enjoy the panoramic view of Virginia's southwest landscape. Hungry Mother State Park is listed in the National Register of Historic Places, as are all the CCC-built state parks in Virginia. Given their historical significance, future development on these parks must be consistent with the CCC design. (Courtesy of Smyth County Historical & Museum Society Inc.)

Seven

TODAY'S LEGACY

On June 15, 1936, Virginia opened six state parks. On July 3, Shenandoah National Park was dedicated. These places provided a much needed respite for families that were struggling in the sixth year of the world's Great Depression. The white-sand beaches and modern swimming pools, hundreds of miles of trails, campgrounds with modern bathhouses, and cabins with water and electricity were cutting edge. More than 80 years later, those facilities still exist and are among the most popular recreation facilities in the state.

Since 2002, Virginia State Parks has operated a Youth Conservation Corps (YCC) built on the basic tenets of the CCC. The program is for 14- to 17-year-olds and is three weeks long. In those three weeks, they learn to live and work with people they do not know and are taught to use the same hand tools the CCC used. They learn the importance of stewardship of natural resources and the importance of citizenship. They work on trails, plant trees, clear invasive species, and build structures that enhance the park visitors' experience.

FDR exclaimed, "The only thing we have to fear, is fear itself," and he created the Civilian Conservation Corps. President Kennedy said, "Ask not what your country can do for you, but what you can do for your country," and created the Peace Corps. Today, there are relatively small Youth Corps, AmeriCorps, and Conservation Corps programs all across the land, emulating the guiding principles of the CCC.

Despite the success of the CCC and the modern programs that emulate it, America is again at a crossroads. Our infrastructure of bridges, roads, schools, and parks is crumbling. Bringing the nation's unemployed and underemployed youth, including white, black, Hispanic, and Asian, together and providing jobs, social skills, and education might be a recipe for getting the country's diverse citizenry working for the common good.

In 2002, this tiny metal cabin at Shenandoah River State Park became home to two youth involved in a conservation corps experiment. From this humble, one-room shack sprung a vibrant Virginia Youth Conservation Corps. Today, the program is offered at nearly every state park. It is a three-week residential program that teaches the same life skills taught by the CCC in the early 20th century. (Authors' collection.)

Youth between 14 and 17 years old are organized in teams of 10 that spend three weeks together working and living in a state park. Three supervisors work with the park staff to develop meaningful projects that, like the CCC, benefit the natural, cultural, and recreational treasures. Pictured is a group of boys at Natural Tunnel State Park in Scott County, Virginia. (Courtesy of Virginia State Parks.)

Like the boys of the CCC, it is common for YCC crews to take a photograph with the main park sign to commemorate their work at the park. Above is a YCC crew that includes the authors' son Lance (top row left) when he served as a crew leader. This crew served at both Natural Tunnel State Park and at the Southwest Virginia Historical State Park. Below are, from left to right, Ishmael Richardson, Arthur Cope, Craig Seaver (then the park's manager and now the state parks director), Marty McConnell, and Col. Gaston Rouse at Natural Tunnel State Park. (Both, courtesy of Virginia State Parks.)

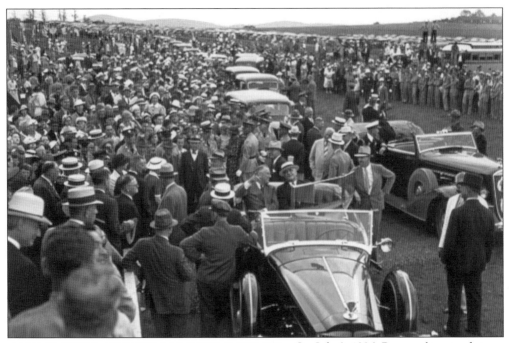

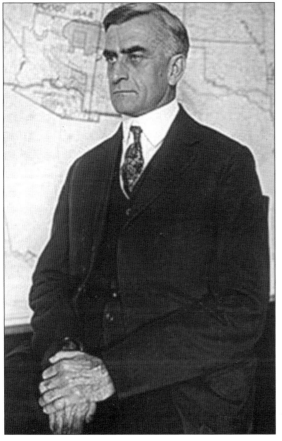

On July 3, 1936, Roosevelt arrived at the grand opening of Shenandoah National Park. As the picture above attests, it was a big and exciting day with a large crowd. Seated to Roosevelt's left in the car is Virginia governor George Peery. He had participated several weeks earlier at a similar event at Hungry Mother State Park near Marion. On that day, he was the keynote speaker at the grand opening of Virginia's state park system. Six brand-spanking-new state parks, all CCC legacy projects, were opened on a single day. More than 5,000 people attended the event. In two weeks' time, the CCC had demonstrated to the nation that they were capable of doing big things. These leaders dreamed about how they could make America better, and they provided the leadership to get there. (Above, courtesy of CCC Legacy; left, courtesy of Virginia State Parks.)

The Civilian Conservation Corps Museum at Pocahontas State Park in Chesterfield County captures the enormity and the accomplishments of the CCC. The museum was created in a small CCC building overlooking Beaver Lake, a CCC-built lake, across the parking lot from the Pocahontas Heritage Amphitheater, which was also built by the CCC. A beautiful map and drawing case houses original CCC drawings and blueprints for many of the structures in Virginia state parks. In addition to the exhibit depicting life in the barracks, the museum offers a film that portrays what conditions in the nation made the establishment of the CCC not only necessary, but also a lifesaver for many American families. Another museum is managed by the CCC Legacy at the US Forest Service Lee District Headquarters in Edinburg, Virginia. (Both, authors' collection.)

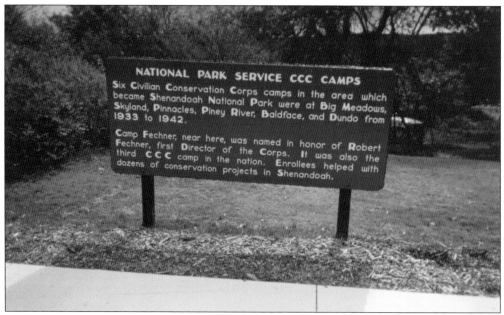

Eighty years after Shenandoah and Prince William Forest National Parks opened for the public's recreation—or re-creation as Roosevelt and others referred to the beneficial impact of time spent in nature—these parks are still serving up health and well-being benefits to their visitors. The kitchen pictured below is in Group Camp No. 2 at Prince William Forest Park. The kitchen and the dining hall it is associated with have been in continual service since 1936. Many groups from Northern Virginia and Washington, DC, have hosted urban youth in this outdoor setting that has not changed much over the decades. Campers exploring the streams, lake, and forests have been exposed to the awe and wonder of nature. (Above, courtesy of US Forest Service, Lee Ranger District; below, authors' collection.)

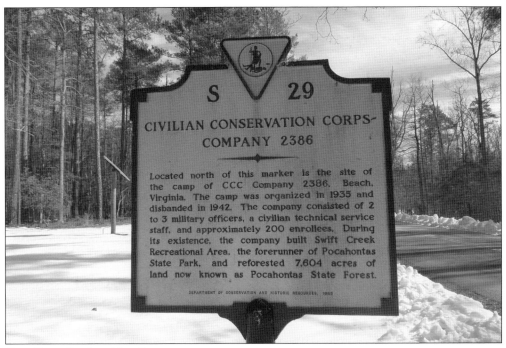

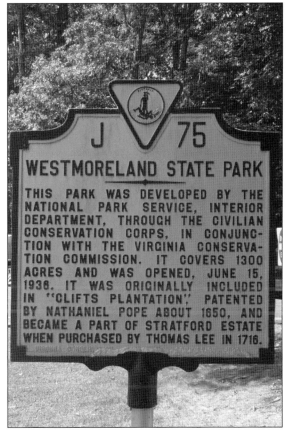

Gov. Harry Byrd and his Conservation and Development Commission chairman William Carson imagined that a historical marker program would entice and educate motorists about Virginia's rich history. They launched the program in 1927 with a handful of markers erected along US Route 1 between Richmond and Mount Vernon. The program was designed to commemorate people, places, and events of regional, statewide, or national significance. Originally, the program was managed by the Conservation and Development Commission. In 1949, the Virginia Department of Highways took over the program, and since 1966, it has been managed by the Department of Historic Resources. Today, there are more than 2,500 markers. Virginia was the first state to adopt a highway historical marker program. (Both, authors' collection.)

On September 9, 2016, ninety-four-year-old Walter Atwood gave an interview to coauthor Patty Elton and spoke at length, without notes, to the staff at Westmoreland State Park. Atwood joined the CCC in 1939 after graduating from high school and helping with the fall harvest at his home in Kansas. He was shipped to Wyoming for training and then off to Idaho. He had taken typing in high school, and when he enrolled, he was listed as a typist/clerk, which turned out to be a very comfortable job. He served two six-month stints before entering the Air Force. He dropped supplies to troops in the Netherlands and in the Philippines. Atwood served as an officer with the National Association of CCC Alumni, which merged with the Camp Roosevelt CCC Legacy Foundation to form the Civilian Conservation Corps Legacy in 2007, and served as one of its founding members. He is pictured in his green CCC shirt. (Authors' collection.)

Westmoreland has undergone major renovations and additions to what was built by the CCC in the 1930s. Major storm surges on the Potomac River have required renovation of the park's pier, boat launch, docks, Potomac River Retreat, and bulkhead. A new visitor's center was constructed on top of the Horsehead Cliffs, and park engineers have installed riprap along the river to retard cliff erosion. Below is a CCC water fountain along the park's entrance road that was recently restored by the park staff with help from YCC crew members. It is located near where Camp Stratford once stood. Pictured above is CCC member Walter Atwood with Westmoreland State Park staff. From left to right are Thomas Stevens, James Wyman, John Fury, Kenneth Ashdown, Walter Atwood, James Ketner, Manager Ken Benson, William Sisson, Alexandra Lyth, Bob Watts, and Wayne Lee. (Both, authors' collection.)

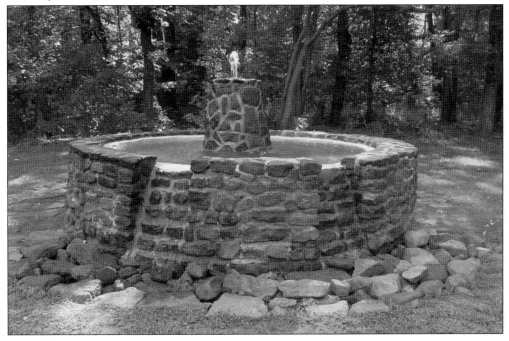

The Prince William Forest mess hall stands sturdy, providing guests a climate-controlled facility. Users from all walks of life have passed over its threshold, including national and state park leaders, youth corps, community organizations, and church groups. Throughout its 80-year life, the original structure remains intact thanks to the hard work of Company No. 2349. (Authors' collection.)

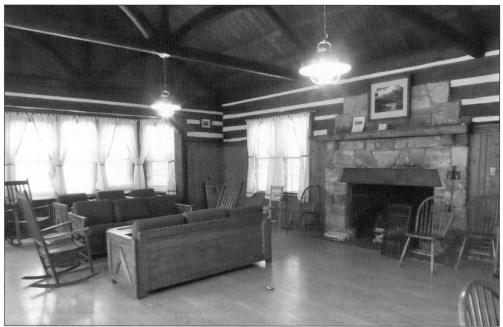

Throughout America, many CCC structures have been consumed by time. Virginia is fortunate to have many that have stood the test, including the Douthat Lodge built by Company No. 1378. It remains a comfortable destination for families and groups retreating to the outdoors, just as FDR had planned. (Authors' collection.)

Since 2011, Virginia State Parks has engaged 209 individuals as AmeriCorps members. These members have contributed nearly 190,000 hours of service to the commonwealth, improving 715 miles of trails on public lands and providing environmental education programs for thousands of visitors. They also assist with controlling invasive species, building habitats, and monitoring prescribed burns. AmeriCorps's mission is: 1. Getting Things Done, through demonstrable service that helps solve community problems; 2. Strengthening Communities, bringing together Americans of all ages and backgrounds; 3. Encouraging Responsibility, enabling members to explore and exercise their responsibilities toward their communities, families, and themselves; and 4. Expanding Opportunity, enhancing members' educational opportunities, job experience, and life skills. Pictured above is AmeriCorps crew member Hannah Lee. (Courtesy of Virginia State Parks.)

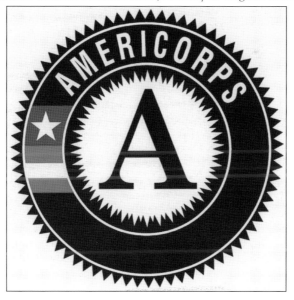

Coauthor Patty Elton (left) is pictured with Joan Sharpe, president and founding member of the CCC Legacy board of directors. Sharpe manages the CCC Legacy's extensive archives and the CCC Museum located at the George Washington National Forest Lee District Headquarters in Edinburg, Virginia. The CCC Legacy is dedicated to research, preservation, and education to promote a better understanding of the CCC and its continuing contribution to American life and culture. Edinburg was the location of Company No. 322, which, along with Company No. 3363 in nearby Luray, were the first two camps formed on April 17, 1933. (Both, authors' collection.)

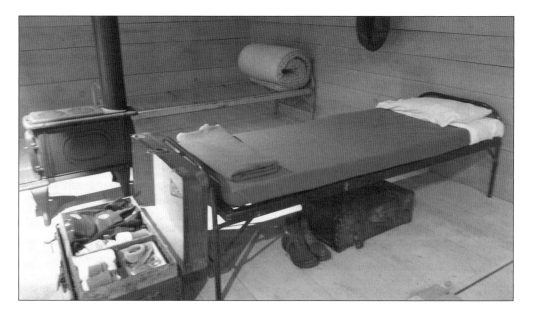

Col. Gaston Rouse served in the US Army Corps of Engineers. After retiring, he took a job with Virginia State Parks to establish a new YCC. Joe Elton, director of parks, knew having the colonel direct the program would be true to CCC roots. In 2010, Rouse proved him correct. The Department of the Interior's Take Pride in America program named Virginia's Youth Conservation Corps the best youth volunteer program in America. Pictured below are, from left to right, Robert Munson, Colonel Rouse, and Joe Elton. All retired from Virginia's Department of Conservation and Recreation. Munson, a Vietnam Marine vet, began his post-military career as a YCC program leader in the 1980s. When with Planning and Recreation Resources, he developed master plans. (Both, authors' collection.)

Pictured above, Joe Elton (left) and Craig Seaver worked together for more than two decades. In 2014, Seaver succeeded Elton as state parks director. Virginia has had only seven state park directors since 1936: R.E. Burson (1936–1939), Robert O'dell (1939–1961), Ben Bolen (1961–1981), Ronald Sutton (1981–1991), Dennis Baker (1991–1994), Joe Elton (1994–2014), and Craig Seaver (2014 to present). Elton and Bolen both served during their tenure as president of the National Association of State Park Directors. Pictured below are, from left to right, Ben Bolen, Ronald Sutton, Barbara Jackson (secretary to all four directors), Joe Elton, and Dennis Baker. (Above, authors' collection; below, courtesy of Virginia State Parks.)

Since 2002, Virginia has hosted 241 YCC programs for 3,000 participants. YCC crews have provided 385,600 service hours valued at $10 million. The value goes well beyond the projects. "Working with YCC is the most important thing I do all year," said chief ranger Craig Guthrie of High Bridge Trail State Park. "As a crew member and crew leader I saw people and places transformed by the YCC," said Lance Elton. State and national parks host a billion visits a year. A quarter are to national parks and three-quarter to state parks. Annually, outdoor recreation represents $646 billion in spending, 6.1 million jobs, and $80 billion in tax revenues. Virginia's state parks have been nominated three times a semifinalist (1999, 2001, 2013) for the National Gold Medal Award. From 2001 to 2003, they were voted America's best. (Above, authors' collection; below, courtesy of Virginia State Parks.)

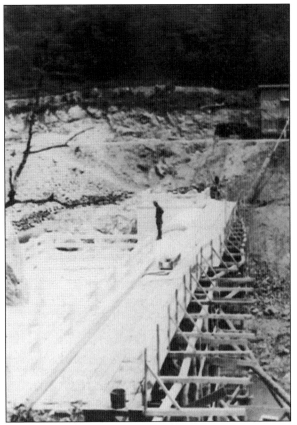

Three camps were established at Natural Bridge Station in Rockbridge County: Company No. 1395, NF-13 (founded July 13, 1933); Company No. 2345, NP-13 (founded January 18, 1936); and Company No. 3340, F-13 (founded November 13, 1941). Near Natural Bridge, Camp F-13 built the Cave Mountain Dam, a structure 30 feet tall and 100 feet long that creates the seven-acre Cave Mountain Lake, which is the centerpiece of Cave Mountain Lake Recreation Area in the 60,000-acre Glenwood district. In addition to the dam, the boys built 100 miles of foot trails and 18-foot-wide forest roads to help with firefighting and telephone lines. Visitors enjoy fishing, swimming, hiking, camping, birding, and wildlife viewing. (Both, courtesy Capt. C.U. Bauman Collection, Washington and Lee Library.)

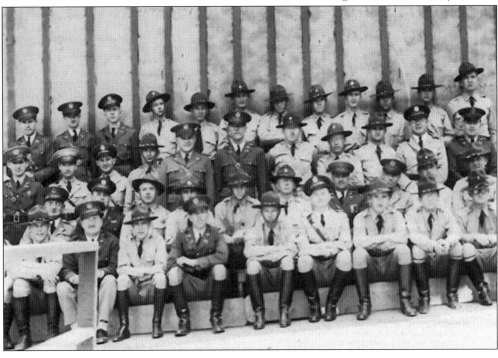

The Monacan Indians called it the "Bridge of God." Thomas Jefferson called it the "most sublime of Nature's works." Since September 24, 2016, it is called Natural Bridge State Park, a National Park Service–affiliated site and National Historic Landmark. It is 215 feet high and 90 feet wide. Thomas Jefferson purchased it from King George III of England in 1774 for 20 shillings. Niagara Falls and Natural Bridge were two of the most popular tourist attractions Europeans visited in the 18th and 19th centuries. (Courtesy of Jennifer Bell.)

The Virginia Conservation Legacy Fund purchased Natural Bridge in 2014 to preserve it for future generations. A conservation easement signed by Joe Elton on behalf of the commonwealth was signed that same year, which protects the bridge in perpetuity. Pictured below at the grand opening of Natural Bridge State Park are Denise Ryan, NPS deputy director; Tom Clarke, president of the Virginia Conservation Legacy Fund; Molly Ward, secretary of natural resources; Craig Seaver, state parks director; and Gov. Terry McAuliffe. (Courtesy of Anne Stuart Beckett.)

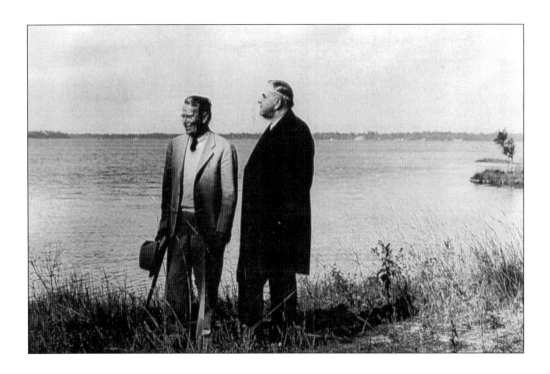

R.E. Burson, the first state parks director, is pictured above with former governor E. Lee Trinkle of Wytheville. Trinkle served as Virginia's 49th governor, from 1922 to 1926. He supported women's right to vote and building state and national parks. They are standing on the shores of the Chesapeake Bay near First Landing State Park, where the Virginia Company first set foot on the North American continent in 1607. (Both, courtesy of Virginia State Parks.)

The CCC Worker Statue graces the CCC Legacy Plaza at Lee Ranger District Headquarters, which includes a commemorative wall and museum. The statue's inscription reads, "The memorial reminds us of the millions of CCC men who toiled between the years 1933–1942 to improve the management of our nation's natural resources and build the infrastructure of our outdoor recreation system. Their accomplishments are unequaled and are a testament to the hard work, pride and determination to overcome the social and economic strife of the Great Depression." The statue is based on a photograph of CCC member John Selesky. Sculptor John Gooden of Oklahoma created the statue cast. For information about CCC Legacy's work or to donate, visit www.ccclegacy.org. (Authors' collection.)

DISCOVER THOUSANDS OF LOCAL HISTORY BOOKS
FEATURING MILLIONS OF VINTAGE IMAGES

Arcadia Publishing, the leading local history publisher in the United States, is committed to making history accessible and meaningful through publishing books that celebrate and preserve the heritage of America's people and places.

Find more books like this at
www.arcadiapublishing.com

Search for your hometown history, your old stomping grounds, and even your favorite sports team.